THE BRITISH LIBRARY GUIDE TO

Manuscript Illumination

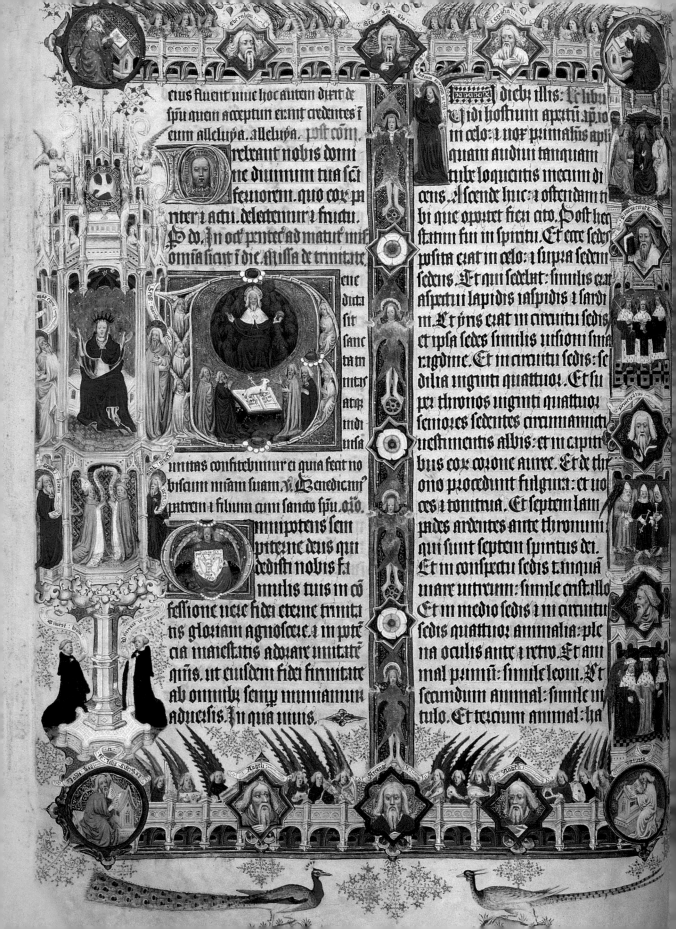

THE BRITISH LIBRARY GUIDE TO

Manuscript Illumination

HISTORY AND TECHNIQUES

Christopher de Hamel

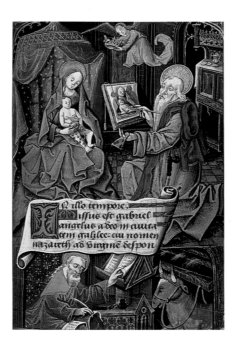

THE BRITISH LIBRARY

COVER *BL.Harley MS. 2952, f19v* (border), *BL. Add.MS. 54180, f.10v* (inset)

TITLE-PAGE The vast Sherborne Missal was written and illuminated in south-west England around 1405. It includes illustrations not only of the patrons, who paid for the book, but also of the principal scribe and illuminator, who executed the commission. In the left-hand margin are kneeling figures of Richard Mitford, bishop of Salisbury 1396–1407, dressed in pink, and, facing him, Robert Bruyning, abbot of Sherborne Abbey 1385–1415. Below them are two clerics in black. On the left is the scribe of the manuscript, John Whas, a Benedictine monk. On the right is John Siferwas, a Dominican friar, the illuminator who designed and painted the Missal.
BL. Add.MS. 74236, p.276.

St. Luke is shown in this French Book of Hours of c.1480 as an artist and, below, as an author. He is reputed to have painted a portrait of the Virgin and Child. He is shown like a medieval illuminator, holding a palate of paints in his left hand as he works on a sheet of parchment held to a sloping lectern by weights on a string.
BL. Add.MS. 20694, f.14r.

First published 2001 by
The British Library
96 Euston Road
London NW1 2DB

British Library Cataloguing in Publication Data
A catalogue record for this title is available from
The British Library

ISBN 0 7123 4613 9

Designed by Andrew Shoolbred
Origination by Culver Graphics
Printed in Italy by Grafiche Milani, Milan

Contents

1–4. This Anglo-Saxon manuscript of the opening books of the Bible translated into Old English was begun in Canterbury in the early eleventh century, but its illustrations were abandoned unfinished. Plate 1 shows a detail from f.148v. Very approximate shapes of colour have been applied over faint sketches. In plate 2, from f.123v, the bodies of people have been outlined in ink and further colours have been added. On f.66v (plate 3) faces have been drawn in and draperies have been emphasised with pale and dark lines of ink. In a completed miniature, plate 4 here from f.57v, the frame has been faceted, outlines have been strengthened and final details such as hair and beards have been inserted.
BL. Cotton MS. Claudius B.IV.

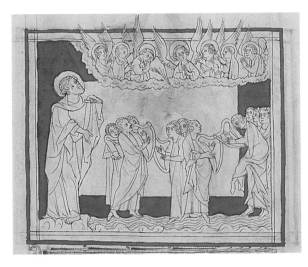

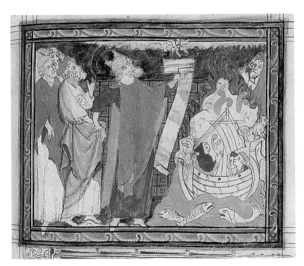

5–8. This is a mid-thirteenth-century Apocalypse, illuminated perhaps in London. The miniatures were drawn first in two colours of ink, brown and blue-black (plate 5, from f.64v). Then gesso was added, mixed with brown pigment, inserted carefully into the areas which would require illumination in gold (plate 6, from f.54v). Once the gold leaf had been laid over the gesso and burnished, other colours could be roughly blocked into place (plate 7, from f.22r). These were gradually worked up with layers of highlights into a completed miniature (plate 8, from f.15r). *BL. Add.MS. 42555.*

9–12. This is a Dutch translation of the *Cité des Dames* of Christine de Pisan, dated 1475. The text was written first, carefully leaving 14 rules lines blank above each chapter opening for the insertion of miniatures (plate 9, f.78r). Designs for miniatures were quickly sketched out in ink, and large blocks of colour were applied rapidly with a brush (plate 10, f.109r). Gradations of colour and outlines were added, leaving the faces to the end (plate 11, f.101r). Pictures were finished with a pen, using black, white and liquid gold, supplying highlights, faces and details of the room and its furnishings (plate 12, f.11r).
BL. Add.MS. 20698.

Introduction

The British Library in London possesses one of the finest and most comprehensive collections of illuminated manuscripts in the world. Including its component libraries, such as the ancient Royal Collection incorporated into what then became the British Museum in 1753, the Library's holdings have taken more than 500 years to assemble. It would be impossible in the space of 80 pages to write a coherent account of all book illumination as represented in that vast and universal library. Let us restrict our boundaries first of all to western Europe and to what we now call the Middle Ages, approximately the period between about 500 and 1500 A.D., the age before the printing press reduced the status of books to repeatable commodities in black and white. A character in the play *Saint Joan* by Bernard Shaw, a notable benefactor to the British Library, is shown admiring an illuminated Book of Hours. 'Now that is what I call workmanship', he says in the play; 'There is nothing on earth more exquisite than a bonny book, with well-placed columns of rich black writing in beautiful borders, and illuminated pictures cunningly inset. But nowadays,' (he continues) 'instead of looking at books, people read them. A book might as well be one of those orders for bacon and bran that you are scribbling.' The extraordinary workmanship of medieval manuscripts has always been greatly admired. The permanent exhibitions in the British Library galleries are spectacular and include some of the greatest works of early European art. A great deal has been published in recent decades on the history of medieval art as it appears in the borders and miniatures of medieval manuscripts, not least the richly-illustrated book by Janet Backhouse, *The Illuminated Page*, 1998, based on the manuscript holdings of the British Library. Instead, let us look at manuscript illumination from a new angle. This book is not concerned with the evolution of style, the biographies of painters or the history of illustration. It addresses the altogether more tantalising themes of why medieval manuscripts were illuminated at all, and how. All illustrations are from examples in the British Library.

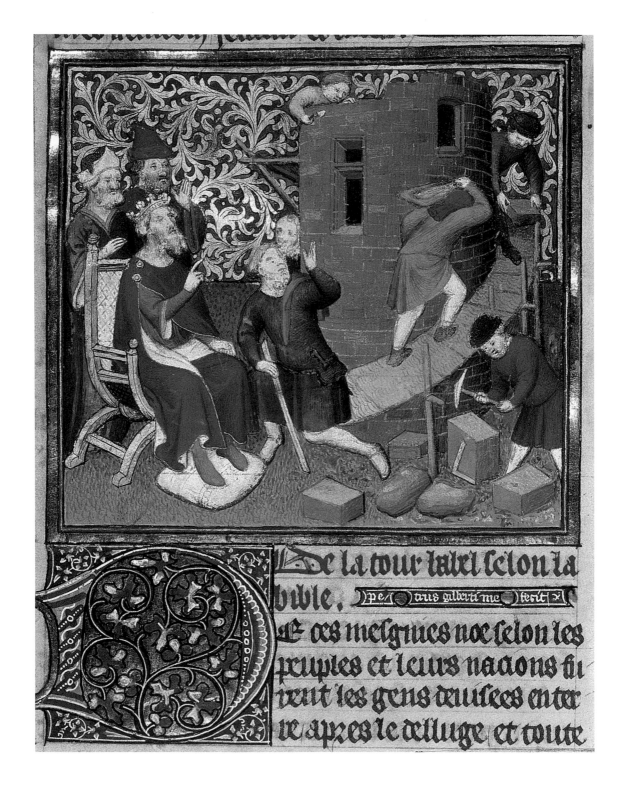

Why manuscripts were illuminated

This book is concerned with preparing and applying the decoration of medieval manuscripts. It was always difficult to make an illuminated manuscript in the Middle Ages. When we confront for the first time any great human achievement of the distant past, such as the Pyramids or Stonehenge or even the fact of the Vikings having sailed to the Black Sea or the domestication of horses, probably the first question any of us will ask ourselves is 'How did they do it?' We know that the makers of Stonehenge or the Viking sailors (for example) had little of the mechanical technology that would make such undertakings relatively simple today. We start to imagine the labour and human effort involved, and we wonder how we ourselves would manage if marooned in the Dark Ages with no other equipment except our hands and what could be found in nature. Such questions are especially intriguing when they concern subjects where technology has now rendered all such effort unnecessary. The time and infinite energy expended by Marco Polo in journeying overland to the Far East in the thirteenth century, for example, has an especial piquancy for the very reason that we can all now travel that same distance in half a day. The fact that some gothic cathedral took more than a hundred years to build (as many did) may fascinate us not so much for the length of time involved but because we know that modern construction methods could erect an infinitely more complex building in a fraction of the time. In few subjects is the contrast of the ages more apparent than in the making of books. The publication you are now holding was probably actually printed (including its illustrations) in a matter of minutes, on a series of computer-driven machines which could – if the publishers wanted it – make many tens of thousands of copies in a few hours. The word 'manuscript' by its very derivation means 'written by hand'. We look in wonder at a medieval illuminated manuscript and can be almost overwhelmed by the infinite human effort which must have been involved. But the short answer to the question 'How did they do it?' is easy. They measured

13. The building of the Tower of Babel is shown in the *Bible Historiale* illuminated in Paris in the early fifteenth century. Perhaps inspired by depicting the theme of craftsmanship, the artist has signed his name in the decorative line-filler below, "pe/trus gilberti me/fecit", 'Pierre de Gilbert made me'. *BL. Royal MS. 15.D.III, f.15v, detail.*

out the pages, copied out the text, drew in the designs, and filled in the colours. It is all as simple as that. The beauty of the final result may depend on the actual dexterity of the craftsman or the function of the book, but the principle was always the same. It was of course often very slow to do, which is part of its fascination. There was no magical trick (at least not until the invention of the printing press around 1450), and all steps were done by hand. That is what defines a manuscript.

14. Medieval manuscripts resemble modern books in all essentials, designed as portable upright artefacts with leaves that can be turned and read from page to page. This is a Book of Hours (one of the earliest known) illuminated probably in Oxford by the artist W. de Brailes, who signed one miniature. *BL. Add.MS. 49999, ff.27v–28r.*

Another aspect of a medieval manuscript which adds to the *frisson* of contrasting the labour of the Middle Ages with the speed of today is that, as objects, medieval and modern books look remarkably similar (pl. 14). A book is still a rectangular artefact, usually taller than it is wide, made up of pages attached along one edge with a flexible fold so that they can be turned. The text is written in lines on each page, one after another, so that the reader can follow the narrative from line to line and from page to page. The whole is enclosed within a hard or stiff cover, which protects the book when it is closed and gives it a certain stability when it is opened up to be read. A thousand-year-old codex works on exactly the same principle. Few artefacts which we use

12

every day have changed so little during the centuries. If some medieval librarian could be miraculously transported to a modern library, he would immediately recognise the objects all around him as books, familiar in shape and form. The greatest physical contrast would come when he opened the books up. Most modern books are printed in black on white pages. The majority of books in libraries today have no pictures and, if they do, the plates are often in black-and-white, or are line drawings in black. Medieval manuscripts, by contrast, are generally ablaze with colour (pl. 15). Nearly every single medieval book, however humble, includes writing in more than one colour, bright red as well as black or brown. Almost every medieval manuscript was designed to begin with an enlarged opening initial, sometimes simply in the same ink as the text, but frequently in patterns of red and blue or in many colours, including gold. A large number of medieval manuscripts have decorated initials and borders on every page throughout the book. Many have miniatures – actual pictures, in many colours. Anyone can take delight in turning the pages of a Book of Hours, for example, even without reading the text. We often use the term 'illuminated manuscripts' to describe medieval books: many manuscripts are not illuminated in the strict sense, meaning decorated with gold or silver which sparkles in the light, but certainly the majority of medieval books include more than one colour and very many are, in fact, illuminated. A medieval scholar, looking for the first time at a modern printed novel, by contrast, would find it of very dull appearance. Colour was a casualty of the invention of printing. The first typographers experimented frantically with multi-coloured printing from as early as the Gutenberg Bible itself in the 1450s, but they were obliged to abandon it as too technically difficult; at first, they left spaces so that initials could be entered by hand, but even this concession to medieval book-production had mostly gone by around 1500. The principal difference between a printed book and a manuscript is not so much in the writing but in integral colour and ornament.

Therefore, in looking at medieval books, we must constantly ask ourselves two questions. 'How did they do it?' is the first; but 'Why did they do it?' is a close second, especially if it apparently took so much time and effort to illuminate a manuscript. Let us therefore consider the function of the principal forms of manuscript colour and ornament, one by one.

15. A principal difference between a medieval manuscript and a printed book is the use of colour. Most printed books are simply black-and-white. Many manuscript pages are ablaze with pictures, decorative borders, and large and small initials. This is the so-called 'Hours of Elizabeth the Queen', a Book of Hours made in London around 1425, inscribed later by Elizabeth of York, wife of Henry VII. *BL. Add.MS. 50001, f.55v.*

16. The opening of the book of Proverbs in the Arnstein Bible is indicated by a variety of visual devices: a table of chapters in small script, a heading in capitals in red ink, and a vast illuminated initial which tapers off as it leads the reader's eye into the block of biblical text. The manuscript was written for the monastery at Arnstein in the Rhineland by the scribe Lunandus in the early 1170s.
BL. Harley MS. 2799, f.57v.

15

Headings

Note how that word 'Headings' is actually written here. There is no universally satisfactory way in modern printing to distinguish a heading from text, except to resort to typographical variants, such as capital letters or italics, or to position it all alone above the first line of text. In a medieval manuscript a heading would probably be written in red ink. It might well be in the same kind of script as the text and in the same size and probably even on the same line, but in a different colour. It could be in other colours (more likely green than blue) or even in letters of burnished gold. In the romanesque period, headings were sometimes in letters of alternating colours, red, blue, green or even purple, as festive as bunting.

The use of red ink for headings in manuscripts goes back at least to late Antiquity. It was standard practice from the fifth century onwards. The opening heading in the book may give the name of the author or of his text, or both, for medieval manuscripts have no title-pages. Subsequent headings mark the beginning of sub-divisions or chapters within the text. The final words marking the end of the text, known as the colophon, are usually also in red. Especially before the ninth century, the script in books was often written as a solid block, with little or no word division. Headings break up the text visually into sections, and make the whole book easier to use. Quite often a heading in a medieval manuscript has a verb, and is grammatically a sentence, such as '*Incipit evangelium iohannis*', 'the Gospel of John is beginning'. It may look like part of the text but it is written in red ink to distinguish it from the text itself. If the scribe was copying a Bible, for example, every word of the biblical text was sacred, but the words of the heading are not actually part of the holy Bible and they are written in another colour to distinguish them (pl. 16). A change of colour assigns a different status to a sentence of text. Note this point, for we will return to it many times. The reason for choosing red rather than any other colour for headings was probably simply convenience. Both red lead and vermilion (mercuric sulphide) were available in Europe from classical times and both make good inks which flow easily from a quill pen, whereas the various mineral components of blue pigments were evidently too gritty for easy use in writing. The word in classical Latin for vermilion was *minium*, and from this evolves our word 'miniature', meaning a picture in a manuscript. The word

'miniature' used in the context of manuscripts has nothing to do with size, but originally referred to the use of red ink.

Headings in red came into their own in Christian Europe especially in liturgical manuscripts. A manuscript written for use in a church service has two completely distinct categories of text. Part of what is in the book is the actual text to be recited or chanted aloud – psalms, hymns, prayers, and so on – which form the worship itself and are, in effect, addressed to God. Other parts of the manuscript are addressed to the clerics or monks who used the book, instructions for when to use different services, what parts are to be sung, when to kneel, and so on. These, then, are written in red. We still call them 'rubrics' from the colour, *rubrum* in Latin (pl. 17). Sometimes major rubrics are written in red script (such as the names of the church feasts) while lesser headings, such as some small variation to a text during a special season, are in black but underlined in red. Once again, a level of relative importance is assigned by the use of coloured ink. A liturgical manuscript, such as a Missal or a Breviary, is often immediately recognisable by its magnificent swathes of bright red colour through its blocks of black script. Without the colour, the book would have been almost unusable.

A very frequent use of coloured inks in the Middle Ages was in the writing of Calendars (pl. 18). These are extremely common and are found at the beginning of most liturgical manuscripts, as well as in Books of Hours and quite often in volumes of practical household use, such as books of legal statutes or home medicine. Calendars are formed of lists of the saints' days for each month of the year. Sometimes there may be an entry for every day, and sometimes only a few names for each month. At the simplest level, the saints' names are written in black, with major feasts (Easter, Christmas, the Annunciation, and so on) written in red ink to give them a different status. A 'red letter day' was a feast of especial importance. Sometimes there is a further grading of importance, with minor feasts in black, festivals of middle importance in red, and the major feasts in blue or gold. Occasionally the scribes opt for a whole series of festive colours, like Neapolitan ice-cream, with stripes of many colours in which mere red has a comparatively low status. In Calendars written in Paris (especially) in the fifteenth century, the whole grading is devalued or beautified to the point where the humble everyday saints are listed in alternate lines of red and blue, and major feasts are in burnished gold. The important point is that relative status is designated by colour.

17. (ABOVE) The text here is written in two colours, red and dark brown. The red is used to denote the names of religious feasts (introducing the service for Corpus Christi in line 7) and for giving the sources of readings from the Bible. The manuscript is a mid-fourteenth-century Lectionary which belonged to the Sainte Chapelle in Paris.
BL. Yates Thompson MS. 34, f.116v.

18. (OPPOSITE) The Calendar of the Queen Mary Psalter, illuminated in England around 1320, shows a sophisticated use of different coloured inks. The heading for the month of August is written in letters of burnished gold. The entries for regular saints' days are written in lines which alternate between dark brown and bright red. More important feasts are entered in dark red or bright blue, such as St. Margaret in the fifth line and St. Mary Magdalene in the seventh. The most important saint's day of all, that of St. James the Apostle, is written in gold in line 10.
BL. Royal MS. 2.B.VII, f.78r.

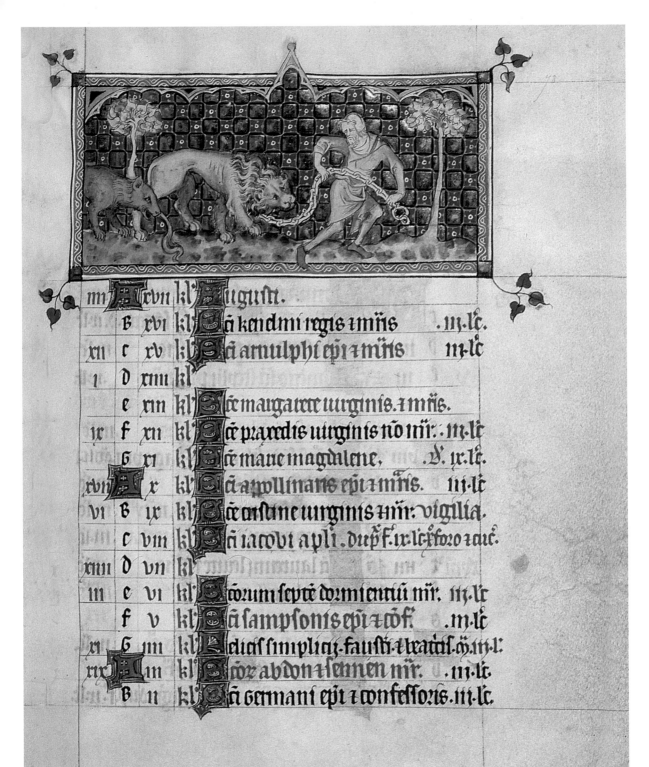

iiii	A	xvii	kℓ	Augusti.		
	b	xvi	kℓ	ꝯ kenelmi regis ⁊ mꝭs	.iiii.lc.	
xiii	c	xv	kℓ	ꝯ arnulphi eṗi ⁊ mꝭs	iiii.lc	
i	d	xiiii	kℓ			
	e	xiii	kℓ	ꝯe margarete uirginis. ⁊ mꝭs.		
ix	f	xii	kℓ	ꝯe praxedis uirginis ñō mꝯ. .iiii.lc		
	g	xi	kℓ	ꝯe marie magdalene.	.v. ix.lc.	
xvii	A	x	kℓ	ꝯi appollinaris eṗi ⁊ mꝭs.	iiii.lc	
vi	b	ix	kℓ	ꝯe cristine uirginis mꝯ. vigilia		
	c	viii	kℓ	ꝯi iacobi apḷi . dupℓ f. ix.lc ꝯ foro ꝛaue		
xiiii	d	vii	kℓ			
iii	e	vi	kℓ	ꝯorum septē dormientiū mꝯ. iiii.lc		
	f	v	kℓ	ꝯi sampsonis eṗi ⁊ coꝫf.	.iiii.lc	
xi	g	iiii	kℓ	ꝯelicis simpliciꝫ fausti ⁊ beaticis. ꝯ.iiii.lc.		
xix	A	iii	kℓ	ꝯor abdon ⁊ sennen mꝯ. v. iiii.lc		
	b	ii	kℓ	ꝯi germani eṗi ⁊ confessoris.iiii.lc		

Initials

The Middle Ages had a very developed sense of hierarchy, a feeling for the fitting order of things far more sophisticated and inflexible than our own. Relative levels of status applied in every aspect of the world, and even beyond it, as in the precise and feudal ranking of the angels in order of importance, or of the saints in Heaven, each according to his or her rank (pl. 19). On earth, the hierarchy of the church was unambiguous, and there were robes of different colours appropriate for every rank. Secular society was ordered very precisely from peasant up through villein to knights, lords, kings and emperors. It all presupposed that God created the universe according to an absolute pattern of hierarchy. Any well-educated man of the thirteenth century could probably have explained even the relative hierarchy of plants, animals, metals, stars, planets, and so on. The order of the importance of things was at the core of the medieval world. In artistic terms, an artist would often express gradations of rank by size and by splendour of colour. This is important. In a New Testament scene, for example, Christ would be shown larger than an apostle, who would be bigger than a mere bystander in the picture, while the humble donor of the painting or the artist himself might appear as a tiny figure in the corner.

Any modern printed sentence shows how this medieval feeling for hierarchy has survived in script even today. This last sentence shows it, and so does this. Notice the capital 'A' for 'any', 'T' for 'this', 'N' for 'notice'. A capital letter is part of a different alphabet on a higher level of status than what we now call 'lower case' type. Initial letters which draw attention to the start of a new sentence are a medieval invention (there are no capital letters in Hebrew, for example). Enlarged initials at the start of words begin to occur in late classical texts, jaunty little red capitals up against the opening of paragraphs. A scribe was not restricted like a printer to a choice of one or two fonts, and the range of initial sizes could be as infinite as his imagination. It may come as no surprise that Irish scribes were especially inventive. In Irish manuscripts from the early seventh century onwards we find major breaks in the text indicated by a large initial letter, a slightly smaller second letter, and even smaller third letter, and so on, gradually diminishing in size, as if the scribe began by shouting to gain attention. The first letter could be as large as full-page, as in some of the great insular books, like the Lindisfarne Gospels (pl. 20) or the Book of Kells. The

19. A sense of the hierarchy of things pervaded the Middle Ages. It was believed that the universe was created with all its components ranged in an inflexible order of relative importance. This fifteenth-century Florentine image of the court of Heaven ranks figures by size. God is the largest of all. Next in size are the Virgin Mary and St. John the Baptist. Other saints and higher angels are shown slightly smaller. The lesser cherubim and seraphim are smaller again.
BL. Add.MS. 30014, f.145r.

subsequent letters gradually get smaller and smaller as the manuscript progresses, until they merge with the scale of the text itself. It gives a graded and visual fanfare to the opening of a book, a paragraph, or even a sentence. Perhaps Irish monks did literally shout the first words of Gospel readings as they preached Christianity across northern Europe in the sixth to the eighth centuries.

Let us remind ourselves that all writing is only a way of representing the sounds of human speech. Actual conversation is full of emphasis, pauses, words spoken quickly and others enunciated slowly, and so on. Public speaking is enhanced with many gestures which are lost when the words are translated into writing. Modern printed books attempt to convey some of the rhythms and emphasis of speech by a

20. (OPPOSITE) The opening of St. Mark in the Lindisfarne Gospels shows the letters of the text diminishing in size line by line as the text progresses down the page. This is characteristic of early Irish and Northumbrian manuscripts. The Lindisfarne Gospels was written in the very late seventh or early eighth century.
BL. Cotton MS. Nero D.IV, f.95r.

21–24. The size of illuminated initials demonstrates the hierarchy of the different parts of the text in the Bedford Hours and Psalter, illuminated in London about 1420. The most important opening of the text, Psalm 1, begins with an initial the height of 8 lines of ordinary text (plate 21, from f.73r). Each of the principal subdivisions of the Psalter is marked by an initial as high as 7 lines of text (plate 22, from f.183r). Ordinary psalms begin with initials which are only 2 lines in height (plate 23, from f.7r). Individual verses within the psalms are marked by initials only one line high (plate 24, from f.183r).
BL. Add.MS. 42131.

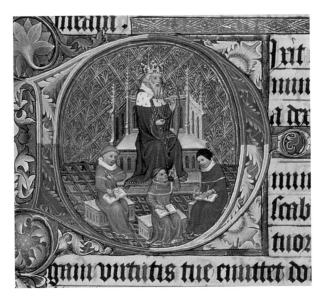

whole series of typographical conventions, including indented paragraphs, spaces between sentences, capital letters, italics, and a large repertoire of punctuation marks, including the frequent use of commas. Medieval punctuation was haphazard, at best. Mostly, scribes made use of what we would now call decoration. A big initial marks a major opening or division of the text. A slightly smaller initial may indicate a chapter or paragraph of somewhat lesser significance. A small illuminated initial marks a break in the text less weighty than a larger initial but more important than a simple capital letter.

The hierarchy depended not on any standard size as such but on the scale of any initial in relation to another in the same manuscript (pls. 21–24). In one manuscript, for example, the highest level might be an initial 3 lines high in red, with penwork in blue; a middle-ranking textual division might be a 2-line initial in red; a simple paragraph break might be a straightforward capital letter heightened with a splash of red paint. In another manuscript, even from the same scriptorium, a major opening might be marked by a full-page design of shimmering burnished gold with a full-page miniature facing it; a medium break might be a large 6-line initial with a full border; and a paragraph might be marked by a 3-line illuminated initial with a border in one margin only. Value is only assigned to decoration in relation to other ornament in the same book. Once the relative hierarchy is put in context, however, we have a whole new tool for interpreting medieval texts. In that sense, decoration is a device for reading a text as sophisticated as punctuation is today.

It would be incautious to generalise too much about the range of artistic devices available to medieval illuminators, for these varied immensely from one period and country to another. A Carolingian manuscript of the ninth century would seldom use gold or more than one colour in giving status to a single initial, but would employ a very carefully ordered sense of relative size. A book of the ninth century is quite likely to supplement the status of a major initial by following it with a whole or partial opening sentence in coloured capitals, or even an entire page of painted capitals. A twelfth-century manuscript would generally have its initials in larger size, and in a larger range of sizes, and would increase or decrease an initial's relative importance by using a wider or more restricted number of colours. A twelfth-century manuscript often has its text pages festooned with one-colour initials. A major initial in the same book could easily have petals and

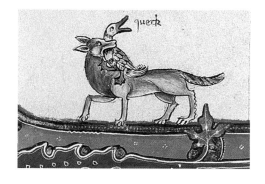

flowers in red, pale blue, green, brown, yellow and other colours; and the status of the initial could be upgraded again by gold or the inclusion of pictures. For elegance of design and an unambiguous sense of the hierarchy of decoration, the twelfth century would be hard to match. It is consistent with the twelfth-century delight in the ordering and classification of knowledge. By the thirteenth century, however, gold had become so common in initials that its value as a barometer of status within the manuscript was degraded. Instead, initials gain scope for demonstrating relative importance by growing bar borders out of their corners and into the margins of the pages. By the mid-thirteenth century, bar borders can sprout from an initial right around a page, and by about 1290 the finest borders in a book begin to include little scenes, like tiny puppet shows, in the space at the foot of the page between the bar border and the last line of text (pl. 25). The heyday for little figures and *bas-de-page* scenes in bar borders was the fourteenth century. Every middle-range initial with a pictorial border forced a top-range initial in the same manuscript into adopting an even more elaborate border. Increasing evidence of status at any level has a knock-on effect on the grade above. By around 1400, borders have become detached from their adjacent initials and they surround the major pages like floating frames (pl. 26). A typical French manuscript of the first half of the fifteenth century might grade its initials as follows, in upward order of status: (1) two lines high in burnished gold on red and blue ground, (2) three lines high in similar colours with a spray of gold leaves in the margin, (3) four lines high in similar colours with a full-length border of burnished gold petals and tiny coloured flowers on black hairline stems, (4) five lines high in coloured flowers on a burnished gold ground with a full border as above but including clumps of coloured acanthus leaves in each corner of the page, and (5) six lines high enclosing a small miniature and with a half-page miniature above, as well as the full border. That gives five clear classes of hierarchy, of which even the most humble was illuminated. By the middle of the century, the borders themselves began to be illustrated. Flemish and some Italian manuscripts of around 1500 often supplement initials with full borders which are themselves fully illustrated, as if the text was on a panel floating in front of a full-page scene. Apart

25. A little picture in the lower margin of the Gorleston Psalter shows a fox carrying off a duck, which exclaims "queck". The manuscript was made in East Anglia at the beginning of the fourteenth century. *BL. Add.MS. 49622, f.190v, detail.*

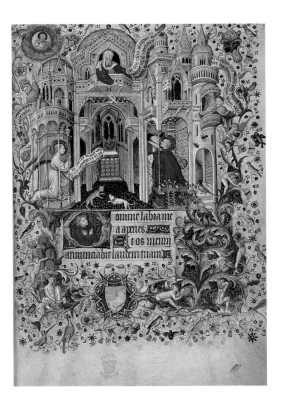

26. The opening miniature of this Parisian Book of Hours of the early fifteenth century extends into the upper margins of the page and merges with the border which entirely surrounds the text. Every corner of the illumination is crammed with life, including frolicking birds, insects and putti.
BL. Add.MS. 29433, f.20r.

27. (OPPOSITE) Several vast manuscripts of the *Bible Moralisée* were made in the thirteenth century. Their illustrations closely resemble stained glass windows. They are teaching texts, relating biblical stories to parallel passages from other parts of the Bible and to their practical relevance to life in the thirteenth century.
BL. Harley MS. 1527, f.6v.

from scattering the borders with *trompe l'oeil* jewellery (which was also done in the sixteenth century), it is difficult to imagine raising the social status of a border any further.

Pictures

There can be many reasons why a book may have illustrations, but the principal purpose is to help convey meaning and to make the book easier to use. At a very simple level, a picture can add detail to a story. A medieval priest with a Bible picture book could read a story to his pupil and could show the illustration to make the tale seem more vivid and perhaps even more credible (pl. 27). A picture could then become the jumping-off point for further discussion and teaching, like wall paintings or stained-glass windows, which were certainly used as focal points to tell and re-tell religious stories. A picture makes a narrative more vivid, and is easier to hold in the mind than a long section of written text. Pictures in the great thirteenth-century Apocalypses may have had this fairly basic function, to amplify a dense and complicated text, and to inspire a rather agreeable sense of fear and impending doom. Similarly, a picture of the Crucifixion in a nun's prayerbook could act as a devotional icon, to focus contemplation and to bring the Passion of Christ closer to the reader's imagination. In a good many medieval texts, illustrations were optional. Copies of identical literary texts, especially, survive with anything from none to many hundreds of illustrations. For such books, pictures were no essential ingredient to the text, but a variable luxury. The pictures probably have the fairly simple function of making the text more vivid in the reader's imagination, and more enjoyable to use. Doubtless the pictures of Amant's trance-like adventures in the *Roman de la Rose*, for example, or the swashbuckling pictures of knights in battle in romances of King Arthur (pl. 28) gave delight to a reader and helped understanding of a text by a noble reader whose level of literacy was perhaps not very high.

26

28. This is a fourteenth-century literary text, the *Roman de Sainte-Graal,* with tales of the knights of King Arthur. The dramatic illustrations of battles and sieges would have helped the reader to comprehend the text and to recreate the scenes in imagination. *BL. Add.MS. 10294, f.81v, detail.*

Many medieval texts had coloured or illuminated diagrams. People in the Middle Ages loved to see order and patterns in things, and readers of manuscripts were probably more visual than we are. Texts on music or mathematics might have coloured drawings which are actually integral to the understanding of the text (pl. 29). Theology and philosophy were sometimes illustrated with elaborate trees, for example, with paired concepts in their branches (pl. 30), or complicated patterns of interlinked circles to show relationships of ideas or people. Every copy of Boethius on music, for example, had elaborate diagrams. Similarly, a text like the popular *Speculum Humanae Salvationis* consists almost entirely of schematic pictures, often with visual puns. In such books, the illustrations are strictly part of the text, and the book might be unusable without them.

In our own time, however, we have an infinite number of books at our disposal, and we mostly read a book only once. We may use pictures to help our minds absorb and comprehend a text we may not

have read before and may never expect to read again. A picture sets a scene in the mind, and thereafter is unnecessary. In the Middle Ages, however, there were probably no more than three or four books in even wealthy households, and a well-stocked monastery might have no more than a hundred or so books in its library. The chances are that any popular text would be read very many times. A Book of Hours was ideally intended for use eight times a day, every day of the year. A volume of the tales of Lancelot might provide fireside entertainment for its owner's whole lifetime. The entire liturgy, including a complete reading of the Bible, was repeated identically every year. Constant repetition and extreme familiarity are features of medieval book reading which are lost to us now. In that sense, a medieval illustration has a very slight value in elucidating a text, for that (one would hope) only occurs in the first reading.

Furthermore, there is an interesting paradox that a very large number of medieval illustrations in books do not (in the modern sense) illustrate their texts. A Breviary may have a well-known picture from the life of a saint to mark the opening of the service for that particular saint's day, such as St.George fighting the dragon, but the picture does not actually illustrate any event referred to in the prayers which follow. Rather, it is a pictorial heading which tells you that the service which it precedes is that of St.George. Good examples of this practice occur in thirteenth-century Bibles. Such manuscripts are very common, and frequently each biblical book opens with a picture within the initial, usually up to a total of 84 historiated initials in the volume. Generally the picture shows the author of the book which follows – David for the Psalms, Solomon for Proverbs, St.Paul for his Epistles, and so on. An author portrait is a late classical device to aid the recognition of a text (pl. 31). Sometimes the initials in thirteenth-century Bibles represent the first words of a text. In British Library, Add.MS. 15253, for example, the book of Judges opens with a miniature of the death of Joshua. The first sentence of Judges opens 'Now after the death of Joshua it came to pass ...', and so on, and the late Joshua is never mentioned again. In no sense does a picture of him illustrate or

29. In this ninth-century manuscript, the coloured diagrams are an integral part of the text, illustrating the subdivision of philosophy into arithmetic, music, geometry, astronomy, and so on.
BL. Harley MS. 2637, f.15v.

30. The Tree of Life illustrated in the fragmentary Psalter of Robert de Lisle comprises an almost entire theological text, represented within an illuminated miniature. The Crucifix is a tree with events of Christ's life in its branches, with the prophecies of the Old Testament in the frame. Text and illustration are inseparable. The manuscript was made in London or Westminster at the beginning of the fourteenth century. *BL. Arundel MS. 83 (part ii), f.125v.*

31. (OPPOSITE) This is from a copy of the *Songe du Vergier* illuminated for Charles V of France in 1378. The text here is the opening of a dialogue between a clerk and a knight. The miniature does not illustrate what they say but shows them speaking. The reader could recognise the text by seeing its participants and could then eavesdrop on their conversation by reading the text. *BL. Royal MS. 19.C.IV, f.6r, detail.*

32. (OPPOSITE) According to legend, the prophet Isaiah was martyred by being sawn in half. This story does not occur in the Bible. However the scene often marks the beginning of the book of Isaiah in medieval Bibles because it was instantly recognisable. *BL. Egerton MS. 2908, f.209r, detail.*

help elucidate the narrative, but it does identify it by representing its first words. Similarly in many thirteenth-century Bibles the book of Isaiah opens with a picture showing Isaiah himself being sawn in half, a story nowhere recounted in the Bible (pl. 32). The apocryphal story of Isaiah's unpleasant martyrdom was graphic enough to have become a popular symbol for Isaiah himself. The purpose of the picture was to inform the reader visually that the book which follows is the prophecy written by Isaiah.

Probably the most famous pictures from medieval manuscripts are those in Books of Hours. They generally follow a standard sequence – the Annunciation at Matins, the Visitation at Lauds (pl. 33), the Nativity at Prime, the Shepherds at Terce, the Magi at Sext, the Presentation in the Temple at None, the Flight into Egypt at Vespers, the Coronation of the Virgin at Compline, and so on. The pictures may have the purpose of aiding meditation or of symbolising events which took place in the Virgin Mary's life at specific hours of the day, but their most practical purpose was simply as a means of recognising the opening of each component of the text. Anyone in the fifteenth century could most easily have found Prime in a Book of Hours by flipping through the pages until he or she found the picture of the Nativity of Christ. Often there is not even a written heading at all. Once one knew the pattern, the Nativity alone would provide the means of recognising Prime. The text of a Book of Hours, however, never actually mentions

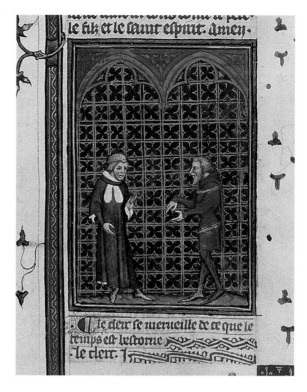

31

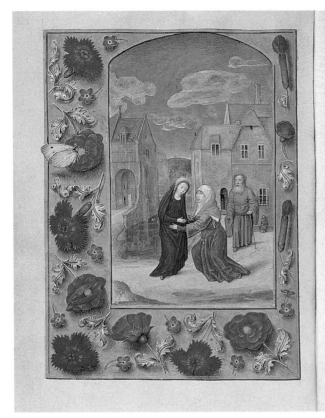

33. The Hastings Hours was illuminated in the southern Netherlands (probably in Ghent) about 1480. This is the opening of the office of Lauds. Anyone using the book would find and recognise this section of text not primarily from the small red heading *"Ad laudes"* but from the presence of a full border and the traditional scene of the Visitation opposite, an image which was the standard indication of Lauds.
BL. Add.MS. 54782, ff.85v–86r.

the Annunciation in Matins, or the Visitation in Lauds, or the Nativity of Christ in Prime, and so forth. The pictures are not actually illustrations of what is written in the text. They may have had a whole series of devotional functions, but their most useful purpose for most medieval owners was as a device to find and recognise visually each of the various sections of a Book of Hours.

Some pictures in illuminated manuscripts seem to have no possible connection with the text. These are some of the most delightful and enjoyable of medieval images. Manuscripts of around the tenth to twelfth centuries often have initials filled with dragons and serpents or little people battling through the foliage with swords. These appear to bear no relation to the texts they adorn. By the late thirteenth century, we start to find line-fillers formed of cartoon animals in coloured penwork, or borders in which strange and wonderful little grotesques crawl around the pages (pl. 34), apes dressed as people, jousting snails, birds in boots, bishops with bare behinds, foxes chasing

32

hounds, romping nuns, and so on, in quite extraordinary variety, sometimes mildly obscene, irreverent and often very comic. One can imagine medieval choirboys falling off their misericords in fits of giggles at the margins of their Psalters. One can sit in a library reading-room today snorting with amusement from the very same thirteenth-century jokes, to indignant glares from more earnest readers at adjacent desks. By the late Middle Ages the borders become broader and even more densely-packed with imagery and multi-coloured hybrid monsters. Without becoming too entangled in the many modern psychological interpretations of medieval grotesques, note two points. One is that these whimsical figures are among the most memorable images in medieval art. The other is that they are especially common in devotional texts which have little or no narrative, such as Psalters or Breviaries, or in books of vernacular literature.

Medieval books generally have no page numbers. It is difficult to find one's place in any text with little sequential narrative. Medieval readers read slowly and usually aloud, even when reading alone. Finding any passage in a volume of hundreds of pages of liturgical or theological Latin must often have been extremely difficult. We have seen how major miniatures acted as a quick method of locating the principal openings of a text, and of recognising the chapters or subdivisions of text. The marginal grotesques must have served the same function for pages of text. The manuscripts were used over and over again. The astonishingly vivid images would impress themselves easily on the reader's memory. In fact, all monks were expected to know the Psalter by heart, and many people learned long texts word for word. The tradition of learning by heart was much more developed in the Middle Ages than in our time. The great literary romances evolved as oral recitations, performed aloud by minstrels or *jongleurs*. There is no doubt that a bizarre or comic grotesque would help bring to mind a page of a manuscript. Strange creatures

34. The Luttrell Psalter, made in East Anglia around 1330, is famous for its startlingly original and imaginative illuminated borders. Every page is different. The more bizarre the images, the more memorable they are to anyone who turns the pages. The borders can thus serve as a visual aid to recognising and memorising every page of text.
BL. Add.MS. 42130, f.183r.

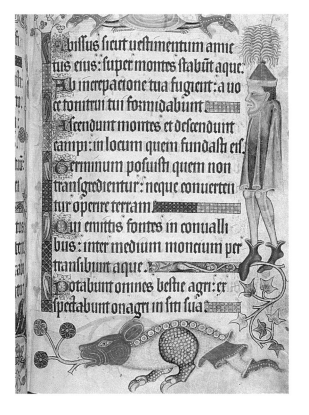

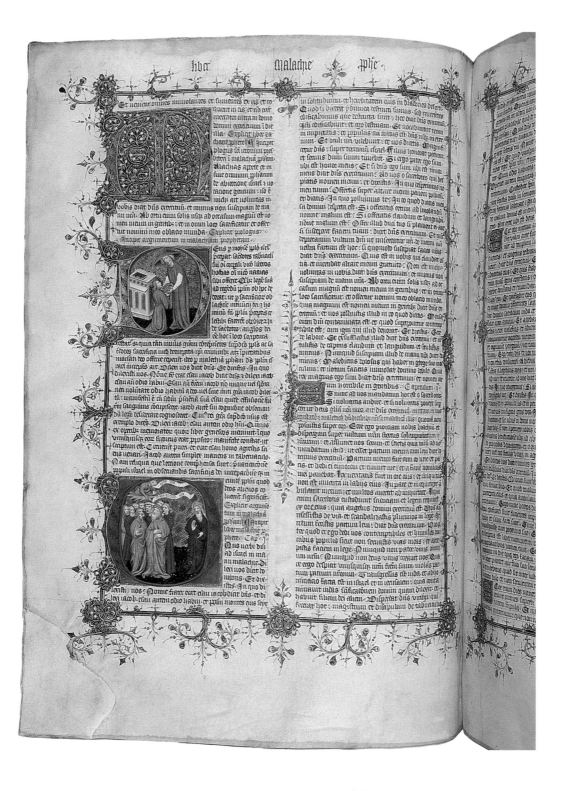

and borders would have provided a very effective kind of visual mnemonic. In fact, the more extraordinary they were, the more effective. They were not simply idle decoration, but furnished one of the basic uses of the book.

Planning and designing the book

Not all medieval books look the same. They can vary very greatly in size and in the arrangement of their pages. Some are truly enormous, such as the vast Bibles of eleventh- and twelfth-century Italy, known as 'Atlantic' Bibles after the giant Atlas who held the whole world on his shoulders. Such books are as large and immovable as pieces of furniture, and indeed they were intended as permanent fittings for a church or refectory (pl. 35). Spanish choirbooks of the fifteenth and sixteenth century are equally gigantic, so that several singers could chant from the same book at once. Other manuscripts are absolutely tiny in size – little devotional books, which can be enclosed in the palm of the hand, or even worn at the waist or around the neck like a talisman (pl. 36). Occasionally they are strange shapes. There are examples of round-topped and almost circular books even in the romanesque period. There is a volume of love songs in the Bibliothèque Nationale de France written in Savoy around 1475 in the shape of heart, and when opened up it forms a pair of hearts joined together (Rothschild ms. 2973). Its format mirrors its subject matter. Books of classical verse are often tall and narrow, as if intended to be slipped into the pocket. Thirteenth-century Bibles and Books of Hours are usually small and easily portable, suitable for reading on the lap. Volumes of the church fathers or legal texts are often bulky folios in size but with quite small script, appropriate for consultation and study on a desk. A Missal has to be small enough to be held comfortably in

35–36. Manuscripts can vary immensely in size and scale, depending on their intended purpose. The two books here are shown to scale with each other. Plate 35 shows a great Bible illuminated in England around 1400, perhaps for Henry IV. Each page is about 625 by 430mm. (24¼ by 17 inches). It was intended for public display on a lectern. Plate 36 is a tiny book of love poetry, made for holding in the palm of one's hand. These are the *Emblesmes et devises d'amour*, illuminated in Lyons around 1500. The pages are 130 by 100mm. (about 4 by 3 inches).
BL. Royal MS. 1.E.IX, f.239v, and *Stowe MS. 955, ff.5v–6r.*

35

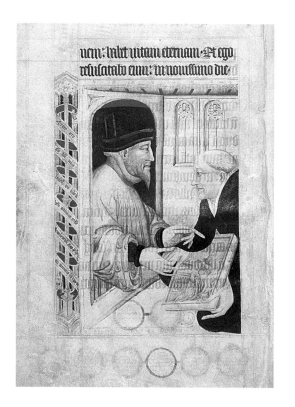

37. Most late medieval manuscripts would be made by an agreement between the patron who paid for the book and the principal scribe or illuminator who executed the work. The Lovel Lectionary was commissioned in south-west England by John Lord Lovel of Titmarsh (d.1408) from the illuminator John Siferwas, who also painted the Sherborne Missal (*see frontispiece* above). The miniature here shows the two men discussing the manuscript.
BL. Harley MS. 7026, f.4v.

the hand, but its writing is disproportionately large, so that the priest could read it clearly at the altar. The purpose of a book will determine its format.

Similarly, the design of the pages will depend entirely on the purpose of the book. Some manuscripts are in one column, others in two. Some texts require a special page layout to fulfil their function, like books of music, or glossed biblical or legal texts with parallel texts in scripts of different sizes. When a patron commissioned a manuscript, he or she would doubtless sit down with the scribe or bookseller and make a whole series of decisions about format, page layout, and decoration. In some form, such discussions would have taken place at every period of the Middle Ages (pl. 37). In the early monastic period, perhaps a bishop or abbot would take decisions. By the time the monasteries had been reformed into a more ordered structure in the eleventh century, the cantor or the *armarius* would probably commission the book from one or more scribes. The cantor would be responsible for liturgical books and the *armarius* for manuscripts in the reference library. Sometimes the scribes were called in from outside the monastery, and were professionals working on contract. Around 1200 we start to find references to booksellers, or stationers, as they came to be called in the university towns. In the fourteenth or fifteenth century, a customer wanting to commission a book would generally have gone to a professional bookseller, who would serve as agent for the whole enterprise. He might also have acted as the scribe. A number of written contracts are known for making manuscripts, and all specify the extent and usually the exact size of the decoration required.

Of course it was normal to write a text before decorating it. Illumination, however, was never an afterthought. As we have seen, all its elements are part of the primal function of the book, and any decisions about what kind of book was needed would necessarily involve plans for decoration, even before the illuminator was ever consulted.

The scribe would need to know, before picking up his pen, what coloured inks would be needed and exactly what spaces to leave for subsequent initials or miniatures, what size each was to be, and what shape (pl. 38). In 1346, the York scribe, Robert Brekeling, had discussed with his client, John Forbor, not only the texts for a Psalter he had agreed to write, but also the number of illuminated initials and their sizes, up to 5 lines high for the opening of nocturns but up to 6 and 7 lines for the principal openings of the book. This was all specified in his contract, which survives. The exact hierarchy of one component of text in relation to another was decided from the very beginning. By the end of the Middle Ages, the illuminators were often quite distinct from the scribes or booksellers, and may well have worked in a different building or even sometimes a different town.

38. This twelfth-century Italian Bible was left unfinished by the illuminator. The script was written first. The exact shape of the planned initial 'F' was left blank by the scribe, who must have rules vertical and diagonal lines across the first column before beginning to write. *BL. Add.MS. 28106, f.97r.*

By the time the artist was brought in, the spaces had already been carefully apportioned.

Decisions were doubtless influenced by the intended purpose of the new book, its size, its text, the level of appropriate luxury or austerity, the availability or not of a suitable pictorial exemplar, supply of pigments, the length of time allowable for the completion of the book, and (probably above all) the price the patron was prepared to pay.

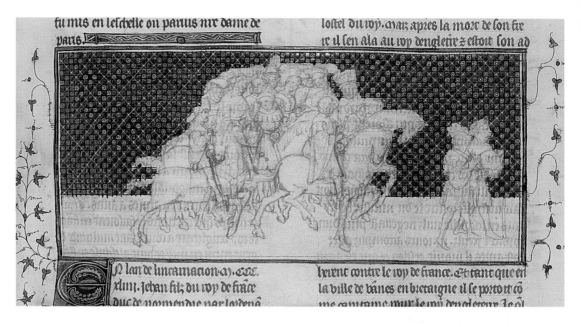

39–40. These details are from an enormous manuscript of the *Grandes Chroniques de France*, illuminated in the late fourteenth century. It was planned with over 200 miniatures, and was to be the work of many artists working together, dividing up their work by loose gatherings. Quires 11–15 were left unfinished. The miniatures here are from that part, finely drawn and framed in burnished gold. The backgrounds have been fully completed but foregrounds and human figures are still blank, probably awaiting a second more specialised artist.
BL. Royal MS. 20.C.VII, ff.93v and 95r details.

How manuscripts were designed

Gatherings

Most medieval manuscripts are made up of gatherings or quires. These are clusters of pairs of folded leaves, fitted one inside another and eventually stitched through their centre fold. A whole series of gatherings sewn together would make up a book (pl. 41). Many modern printed books are constructed of similar gatherings, sometimes called signatures. Look carefully at the book which you are now actually reading: peer into the inner margin four leaves from the very beginning, between pages 8 and 9, and you will probably see the vertical sewing. In other words, this is the centre of a gathering of 8 leaves, pages 1–16. Turn to pages 24–25 and the sewing will appear again. This book is made up of gatherings of 8 leaves each, or 16 pages. The majority of medieval manuscripts were also constructed of gatherings of 8 leaves. Sometimes these gatherings were put together from folding oblong sheets in half and simply enclosing one inside another until they make up a little stack of double leaves. More usually, the gatherings were formed by folding larger sheets of paper or parchment. Imagine taking a sheet of paper or parchment and folding it in half, and then in half again the other way, and in half again a third time. Then slit open the edges with a knife, and you have a basic 8-leaf gathering. Other gatherings in manuscripts occur with 6 or 10 or even as many as 24 leaves. All these can be made by folding large sheets according to a certain method and then cutting open the edges.

When the design of a medieval manuscript was worked out, the parchment or

41. Most manuscripts are made up from a series of gatherings or quires of leaves sewn together to form a book. This illustration, taken in the British Library Conservation Department, shows the separate quires of a disbound Armenian manuscript.

paper would usually have been in the form of a series of loose unbound gatherings. There is some evidence that by the fifteenth century one could actually buy parchment from the stationers already folded and cut into gatherings, ready to use. Even as a medieval book was being written and illuminated, the unit of work would almost always have been the separate gathering. This is important, and its significance will recur many times in this and the subsequent chapter. Gatherings could be distributed among several craftsmen working simultaneously. Differences of design or of style of illumination within a single manuscript will often be found to correspond to a change between one gathering and the next. An interesting documentary echo of a separate gathering being sent out to an illuminator occurs in a chance note in British Library, Royal MS. 20.D.I, a Neapolitan chronicle of ancient history of c.1340 which was being used in Paris around 1400 as the exemplar for another copy. It has a tiny note on f.8v, the last leaf of the first gathering, '*Ci faut le secont cayer que maistre Renaut doit avoir qui fu baillie a Perrin Remiet pour fair lenlumineure de lautre cayer*', 'Here should follow the second quire which Master Renaut should have [and] which was lent to Perrin Remiet to do the illumination for another quire'(pl. 42). The illuminator Remiet (fl.1368–1420) had evidently borrowed a complete gathering of an older book in order to copy its miniatures into another complete gathering of a new manuscript. Another British Library manuscript chronicle of about that date is Royal MS. 20.C.VII. It is partly unfinished and its illumination corresponds exactly to the structure of the gatherings. Quires 2–10 and 18–19 are complete (ff.9–79 and 131–146). Quires 11–15 are illuminated but without human figures (ff.81–114 (pls. 39–40)). The illumination of quires 16–17 and 20–23 is still left blank (ff.115–130 and 147–178). It is quite evident that the book was circulating among the artists in separate gatherings, not even in order.

42. This Italian chronicle was being used as a model for an illuminator working in Paris around 1400. The manuscript was at that time disbound. The marginal note shown here records that the second gathering had been lent to the well-known illuminator Pierre Remiet (fl. 1368–1420). *BL. Royal MS. 20.D.I, f.8v, detail.*

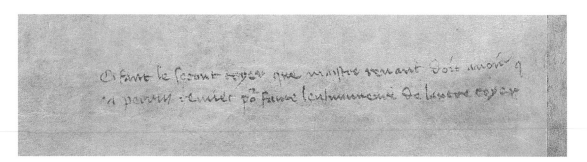

Of course, it is a mistake to generalise absolutely. We are dealing with a huge span of time and scribes and illuminators of widely different experiences and skills. Some scribes certainly worked on separate pages temporarily extracted from the loosely-folded gatherings. Generally, however, most medieval scribes probably kept the whole gathering together while they were actually at work. The leaves must have been held together by some kind of quick tacketing stitch or perhaps a tiny ribbon of parchment threaded through the extreme upper inner corner, just sufficient to keep the unit together. Occasional traces of such ties survive. Medieval pictures of scribes at their desks often seem to show them working on what look like whole manuscripts; discounting artistic conventions which might require a book-in-progress to look like a finished book, scribes depicted in illustrations are probably mostly working on separate but complete gatherings.

Ruling the framework of the page

The first stage of designing a page was to rule it, both vertically and horizontally. Nearly every medieval manuscript was carefully ruled out before the scribe began to write. Nowadays, schoolchildren's exercise books are still printed with lines to keep writing straight and the margins vertical, but it is considered rather shameful to use lined paper for serious handwriting. In the Middle Ages all good scribes wrote on pages with lines, and indeed the ruling often formed a positive part of the decorative effect of the page. To a medieval reader, a page without lines would look unsettlingly naked. When printing was introduced, many incunables had lines drawn in by hand around the pages and between each line of type, for no purpose except to create the reassuring effect of a manuscript.

The first task of all in preparing a blank page for a manuscript was to rule out a rectangle on the page to define the shape of area to be written, usually leaving generous margins on all sides (pl. 41). In basic form, this ruling is made up of four lines, two vertical and two horizontal, usually ruled right to the edges of the page. In more elaborate manuscripts, these frames might often be formed of double lines, especially those which ran vertically. Sometimes the lines are drawn like multiple concentric frames around the block of text. If the manuscript was to be written with two columns to the page, there would be further vertical lines in the middle of the page to mark off an inner

43. The page layout was carefully considered in planning a manuscript. The size of the illustrations in this thirteenth-century Apocalypse have been carefully measured, and the proportions of the text and the surrounding blank margins have been calculated before the scribe began to write. *BL. Royal MS. 19.B.XV, ff.13v–14r.*

margin. It is an intriguing question as to whether the scribe imagined he was marking out the written-space or (perhaps more likely) the margins. It comes to the same thing, of course, but we should not underestimate the importance of margins in medieval books, not just for elegance or to give a buffer zone for dirty thumbs. Margins sometimes became the field for decorated borders outside the area of text, as we saw above. They gave space for long decorative extensions from illuminated initials. They were used for corrections to the text, either by the scribe or by later readers. Margins were often used for glossing – the adding of readers' notes and comments. Modern schoolchildren (and readers in libraries) are discouraged from writing in the margins of books, for we feel that somehow the integrity of a printed page is disfigured by hand-written annotations. When the whole book was written by hand, however, many owners felt no inhibitions about adding more, and the margins of even luxury manuscripts were often used extensively for users' notes and jottings. These can be very interesting, and fulfil one of the functions of a medieval book.

The effect of an open manuscript can often be very beautiful to the eye. This did not occur by chance. In a well-proportioned page, the height of the written area is usually approximately equal to the width of the whole page. The lower margin is usually the widest, and

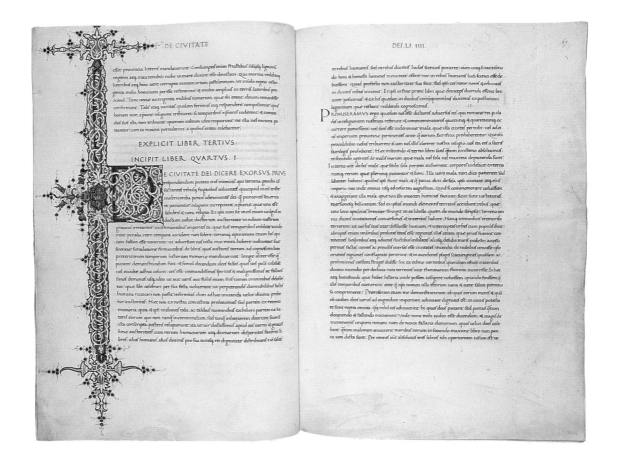

approximately twice the width of the inner margin. In an open book, therefore, the margins between the two pages were the same as those at the foot. The outer margin is about two-thirds of the width of the lower margin (pl. 44). The upper margin is about half that of the lower margin. Such proportions are necessarily very approximate, especially as exact measurements are lost as soon as a book is sent to the binder. When a volume is bound, even the very first time, it is enclosed in a vice and is planed along its three outer edges until the surfaces are neat and flush. Sometimes cruel amounts were pared away, even quite close to the edge of the text. Only inner margins, quite obviously, cannot be cropped, or the pages would fall out. However, this is to anticipate the final stage of making a book. Let us in the meantime return to the marking out of the shape for the rectangle of text.

Once the framework had been measured out on the first page of the unwritten gathering, the designer would follow the lines to the

44. The elegant and uncrowded proportions of Italian humanistic manuscripts are among the most graceful ever designed. This is a Florentine manuscript of St. Augustine, made in the mid-fifteenth century. *BL. Add.MS. 15246, ff.66v–67r.*

extreme edges of the leaves and, with an awl or other sharp point, would prick a hole right through the whole clutch of eight or more leaves. In turning to the next page, then, he would only need to join up these tiny holes to achieve a written-space that was identical on every page, both in shape and in horizontal alignment. The ruling of some medieval manuscripts stopped there, with two vertical and two horizontal lines to mark off the four margins. Sometimes this is the only ruling in very informal books, such as quickly-written student textbooks or volumes of sermons. Generally, however, the central rectangle was then ruled across with a grid of horizontal lines. If the manuscript is in double columns, the ruling looks rather like a pair of ladders. These then become the guide-lines for writing the text – keeping it straight and ensuring a regular number of lines to each page. Usually, every page was ruled with these lines, even those which were intended to be painted over entirely afterwards with full-page illuminations. Horizontal lines can be detected underneath initials and miniatures in many manuscripts (pl. 45). This is actually quite important. One might have supposed that scribes would simply have ruled horizontal lines only on the pages, or parts of pages, to be inscribed

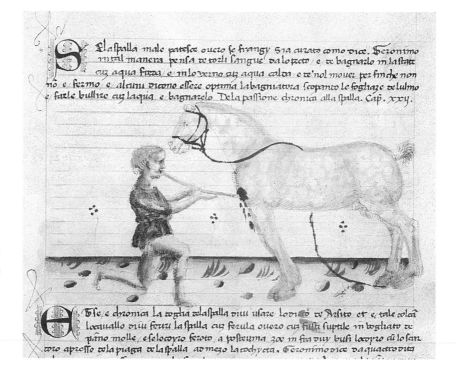

45. A grid of horizontal lines was ruled across every page of a manuscript, even those where illustrations were planned. The lines would provide a framework for copying the script and could serve as a measure of the height and relative proportions of the miniatures. This is a fifteenth-century manuscript of horse medicine. *BL. Add.MS. 15097, f.68r, detail.*

with text. In fact, the horizontal lines had a use in executing illumination too. They were used in measuring the relative scale of illuminations, as we have seen, when contracts specify the varying grades of initials or miniatures to be so many lines high. They also provided a framework for designing the composition of miniatures, with a clear horizontal axis within two vertical bounding-lines, and sometimes details of finished pictures, such as the edges of buildings or tiled floors, can be seen to be echoes of the horizontal ruling which must have been beneath the paint. Often the designs of miniatures were copied from other manuscripts, not necessarily of exactly the same size. In such a case, a grid of equally-spaced horizontal lines might be as useful to the illuminator as the squaring-up lines used by artists in transferring designs of drawings in correct proportion onto paintings of a different size.

The extremities of the horizontal lines, like the vertical frames, were also pricked right through the pages. These rows of holes look rather like marks of stitching in the extreme outer edges of the leaves. In some manuscripts, such prickings are in both margins of a page but generally they occur only in outer margins (and even then have often been trimmed away by the binder). If the holes are at both sides of the page, we can assume the gathering was ruled and pricked with its leaves closed like a book, presumably by measuring up the first page. If the holes are (or were) in the outer margin only, the pages must have been measured and pricked with the pages of the gathering opened up, presumably to the central spread. Then a long ruler would allow the scribe to rule right across each opening, two pages at once. It would, in fact, be sensible to prick all horizontal lines with the pages open, but all vertical lines with the pages shut. This alone demonstrates that they were two distinct activities. At different periods of the Middle Ages, there were various ways of making the prickings. In the early period the holes often look like little slits, probably made with the tip of a knife. Erratic lines of holes may have been made with little wheels, like miniature garden rollers with spikes. Common sense would suggest the usefulness of a special template, with patterns of holes like a stencil, or of some kind of comb with widely-spaced metal pins which could be knocked through the margins with a hammer. However, there seems to be no evidence of such simple devices. Usually the holes seem to have been made with an awl.

The lines themselves were ruled with a variety of implements. Until the early twelfth century, the ruling was usually scored into the

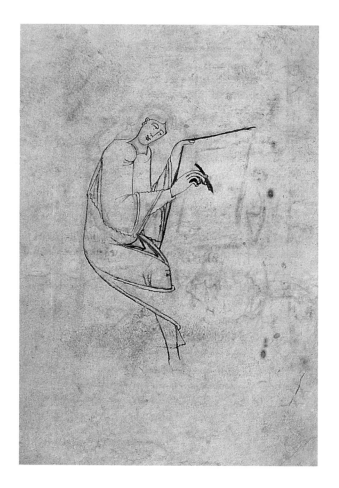

46. (ABOVE) This drawing of a writer or artist occurs in a tenth-century English manuscript of the works of St. Aldhelm. It was sketched first in a pale fuzzy chalk and then partially redrawn in ink. *BL. Royal MS. 7.D.XXIV, f.85v.*

47. (ABOVE RIGHT) In romanesque manuscripts, such as this Gospel Book, the horizontal lines were scored across the page, perhaps with the back of the scribe's knife. The initial, however, was sketched in plummet, probably with lead, and was then drawn carefully in brown ink. *BL. Stowe MS. 3, f.111v.*

page, presumably with the back of a knife (sometimes it cuts into the page by mistake), or possibly with a stylus. On one side of the page the lines appear as indentations and on the other as projections (pl. 47). The advantage of scoring lines is that, with care, a scribe could press hard enough through the parchment to rule several leaves of a gathering at once. A practical problem with scored lines is that wet ink or paint will run easily into the furrow on one side of the leaf and dried pigment rubs off a raised projection on the other, leaving ghostly lines across the design. Both sides therefore look unsightly at close inspection. A Carolingian scribe will usually try to write between the lines, not on them or overlapping them, so as to avoid this effect.

Some time in the eleventh century, scribes first started using an implement which makes a line very like that of a modern graphite pencil. It is used for ruling by one of the scribes, for example, in British

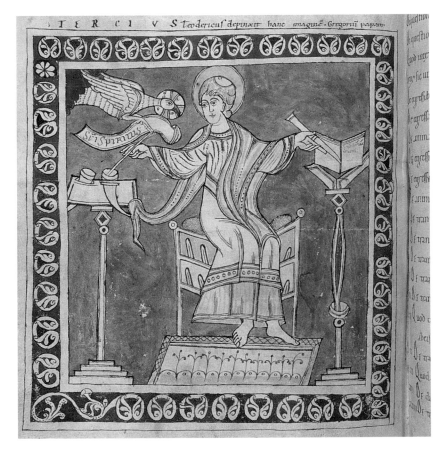

48. Occasionally the names of artists are preserved. This early twelfth-century drawing of St. Gregory writing is inscribed along the top, recording that 'Teodericus' drew this picture. Since the inscription is in the same hand as the text of the book, it is probable that Theoderic was the scribe as well as the artist of the illustration.
BL. Harley MS. 3011, f.69v, detail.

Library Harley, MS. 603, datable to towards the end of the first third of the eleventh century. This ruling style began to become general in Europe by about 1150. One unsolved question for manuscript historians is that no-one really knows how these lines were made. There is some evidence that graphite was already being mined by the twelfth century, but probably the pencil-like lines were made with pieces of plummet, oblong ingots of metallic lead. Maybe sometimes silver or some kind of ferrous metalpoint was used, especially in manuscripts where it has now oxidised into a fuzzy brown colour. Whatever the implement, it was evidently quicker and clearer to rule a line which left a mark on the page than it was to score lines into the surface of the page. Both sides of every page now needed ruling, however.

By the thirteenth century, the guide lines were frequently ruled in ink. This became the normal practice for the late Middle Ages. Some gothic manuscripts were ruled in multi-coloured inks, usually pale red

but sometimes also in green or purple. Italian humanistic scribes of the fifteenth century, in their desire to go back to ancient practices, often reverted to scoring their ruling with indented lines.

Marking out the decoration

Unfinished manuscripts of the late Middle Ages usually show a sequence of work that one would expect, that the script was written first and that the decoration was added afterwards. A good example, among surprisingly many, is British Library, Add. MS. 20811, a large fifteenth-century chronicle of France. Its illumination was never added. It is constructed throughout with blank spaces of several graded sizes for its initials and with large blank compartments for its miniatures (pl. 49). Some pages look very strange, like a wall with random bricks missing. It graphically makes the obvious point that the scribe, picking up his pen, will need to know exactly where to begin on a page, a certain number of lines down from the top to leave space for an opening miniature, making further allowance for an indentation the height of a fixed number of lines for an opening initial whose exact size was very important in the hierarchy of the book's decoration.

Let us begin, however, by stepping back in time. Until the eleventh century, both the script and the decoration of a manuscript were quite often done by a single person, especially in manuscripts where the ornamentation was relatively slight. At that period, most books were probably made in monasteries, and a monk working in the cloister might well be expected to make all aspects of a book, both script and painted initials. If several monks collaborated in making a manuscript, we can suppose that they all worked side by side in a single enterprise. Writing and decorating were often hardly distinguishable activities. In manuscripts where we can detect a change of artist,

49. This fifteenth-century chronicle was fully written but was never illuminated. The scribe has left a space 15 lines high for a miniature and a smaller space 4 lines high for an illuminated initial.
BL. Add.MS. 20811, f.36v.

48

this will usually be found to correspond to a change of scribe. We get occasional glimpses of names, as in British Library, Harley MS. 3011, an early twelfth-century manuscript of St.Gregory: the picture of the author on f.69v is actually signed by its artist ('*Teodericus depinxit hunc imaginem Gregorium papam*' (pl. 48)). This inscription is in the same hand as the text of the book itself. The likelihood is therefore that Theoderic was scribe as well as decorator. Similarly, the Norman monastic artist, Hugo pictor (the second word means 'painter'), shows a little coloured drawing of himself in Bodleian, MS. Bodley 717, f.287v, which he calls '*imago pictoris & illuminatoris huius operis*', 'a picture of the painter and illuminator of this work', but the drawing itself shows a scribe and the inscription is in the scribe's hand. Doubtless the monk Hugo actually wrote the book as well as illustrating it.

Around 1100 we start to find evidence of professional scribes and artists. This was a period of a vast increase in the number of authors writing books and of newly-founded monasteries needing libraries. For a large number of economic and practical reasons, many monasteries found themselves unable to cope with the quantity of texts which were suddenly available. Some monasteries found it expedient to hire professional scribes, '*scriptores*', to help with the copying of books. Other religious houses, such as Bury St.Edmunds or Winchester, might have basic facilities for writing manuscripts but would call upon the services of itinerant artists to supply illuminations. These recruited artisans were doubtless laymen, who made their livings from copying or painting books. The moment that the making of manuscripts became even partly a professional enterprise, the activities of scribe and decorator became separated from each other. This is an important moment in the history of book production. We find this change reflected in an increasingly large number of manuscripts left unfinished. Partially completed books, with the script finished but the decoration left blank, become relatively common from the early twelfth century onwards. This is because the script was written first in one campaign; and the illumination was planned for a second and quite separate stint of activity. Once copying and decorating became distinct activities, a whole new process was needed in designing a book, for the scribe had to leave exact provision for decoration which was to be added at another time or place.

An example is British Library, Royal MS. 1.B.XI, a Gospel Book from St.Augustine's Abbey in Canterbury, written in the second quarter

of the twelfth century. It has been left unfinished and it still includes evidence of the process of planning a book between the scribe and the decorator. The whole book was ruled first with horizontal lines, 24 to a page. Plate 50 here shows f.6v. The scribe wrote the four lines at the top of the page to complete the first prologue to St. Matthew's Gospel, and then, foreseeing a large initial, evidently paused. He, or a designer, marked out a line to be left blank, adding in pale writing *'non scribatur'*, 'not to be written', to leave space for a coloured heading. It was never supplied and, if it had been, the *'non scribatur'* would have been erased. Then the shape of an initial 'S' was approximately roughed out below, indenting two lines some way across the page for the upper bow of the letter and four further lines below extending only partially into the text area. A vertical stroke in plummet separates off this indentation. Thus the scribe was now able to write the rest of the page without straying leftwards into the space marked out for an initial which was not yet there. The initial itself was drawn in subsequently and it actually appears to be the wrong letter, for this is surely an 'I' (or possibly 'L') rather than the 'S' required by the text. Such a mistake could not easily have occurred if the scribe himself had drawn the letter while the exemplar of the text was in front of him. The shape of the initial does not entirely fit the indented shape already allowed for it, and the whole design is still unfinished, for it has never been coloured. It is clear from this troubled manuscript that the sequence of work has changed, not very successfully. In an earlier manuscript made by one man, the initial would have been made in the same process and the script would have flowed around the initial. Now the initial is allowed for, but was intended to be added afterwards by someone else.

50. The page here has been marked up by the designer. After the horizontal lines were ruled, the designer marked off a space for the initial and then wrote an instruction "non scribatur", 'not to be written', in the blank line above the opening of the prologue to St. Matthew's Gospel. *BL. Royal MS. 1.B.XI, f.6v.*

51. (OPPOSITE) Before the scribe began to write, the designer would have marked off spaces for the miniature, the 5-line initial and the line of heading in red. This is the same manuscript as plate 15 above. *BL. Add.MS. 50001, f.74v.*

By the late Middle Ages, the whole layout would have to be co-ordinated very carefully. The monastic process of writing and decorating in tandem was no longer possible, and yet the ornamentation could not be planned entirely in advance. The number and size of required illuminations would be known long before the scribe began work but not exactly where they would occur on any specific page. A designer could plan an opening page without the scribe's participation, but thereafter no-one could predict exactly where illumination would fall until the scribe had reached that point in his copying. The staking out of spaces for initials and miniatures must have happened in parallel with the writing of the text (pl. 51). The scribe himself was therefore either the designer or had the responsibility of implementing the design. Before starting a new paragraph or chapter, a scribe would have to leave a space of the required size. He could indicate its scale by the number of lines he left. He would often write a tiny cursive guide-letter in the centre of the space to tell the subsequent illuminator what initial to paint, for the exemplar of the text would by then no longer be present. The relative scale of the illumination required – its important place in the hierarchy of decoration – would be obvious by the size of the space left for the artist. Even then, however, the precise rank of a requisite initial might occasionally still be unclear from the space allowed, and one sometimes finds microscopic instructions in the margins, such as '*de auro*', an initial to be given enhanced status by the use of gold.

A more complicated problem would be in indicating the need for illuminated borders. This is an intriguing one. As explained above, partial or full borders were used increasingly in the late Middle Ages to supplement the status of illuminated initials and to elevate them to a higher level than initials without borders. A border, however, falls outside the area of written text. A space indented into a block of text

52. This Breviary preserves written instructions for its illuminated border. A 4-line space was left in the lower left-hand corner for an initial "I": because the initial fell at the very foot of the page, there was no scope for a larger space. The illuminator would therefore not have known for certain by the size of this space whether to supply a partial or a full border. The designer wrote "dimie vient" (half border) in the extreme lower margin, and then relented, upgrading it to "hole vynet", or whole border. *BL. Harley MS. 7398B, f.262v.*

would not by itself show an illuminator whether or not the initial should have a border attached. There must have been a whole repertoire of marks to instruct the artist – little dots or crosses, for example, which were either erased or painted over when the border was illuminated. Very occasionally, instructions are actually in words (pl. 52). The scribe of British Library, Harley MS. 629, a fifteenth-century Lydgate, allowed only 3 lines for an initial on the opening page, f.2r, but he asked for a whole border (*'vinet'* in Middle English) in a note in the extreme lower margin, *'hole vynet'*, and indeed the page is now splendidly enclosed in a full border of coloured and burnished gold flowers and leaves. A few pages later, f.4v, the same scribe incautiously left a 4-line space for an initial, inappropriately large for one whose status was relatively less important than that on the opening page: it is therefore marked *'sprynget'*, meaning an initial with a partial border which sprang or sprouted out into two margins. It is thus downgraded without losing size. By chance, the words survive without having been erased.

Most (not all) miniatures in medieval manuscripts are set within the measured central compartment of the page, often the full width of the column of text and up to the full height of the ruled lines. An appropriate blank space would indicate unambiguously the need for some kind of miniature to be inserted. However, while a literate illuminator could often guess accurately what letter of the alphabet was needed for an initial to make sense, the range of possible subjects for pictures was theoretically infinite. Doubtless the artists themselves were occasionally given free rein to read through the text and to choose or design a suitable subject for a space left blank. Normally, however, there must have been two ways that the artist would know what pictures to insert. Either he copied what was already in the exemplar, or he followed instructions left by the scribe when leaving a space.

In some manuscripts the illustrations are an integral part of the text, and an exemplar of some kind must always have been needed for the artist to copy, as (for example) in manuscripts of the Apocalypse or the Bestiary, which are filled with pictures. In such books the miniatures can resemble each other so exactly from one manuscript to another that one has to suppose that they were copied directly. A Bestiary of c.1200 in the British Library, for example (Royal MS. 12.C.XIX (pl. 53)), has an almost twin brother in the Pierpont Morgan Library

53. The artist of this Bestiary, or book of animals, carefully copied the illustrations as well as the text from his exemplar, probably an almost identical Bestiary made about a dozen years earlier (now New York, Morgan Library M.81). This is the picture of a phoenix.
BL. Royal MS. 12.C.XIX, f.49v, detail.

54. (OPPOSITE) The illustration in this early fifteenth-century Old Testament in French shows Abraham receiving the three angels outside his tent. This was a well-known subject (Genesis 18:2). In the margin here, towards the lower edge of the plate, is a faint sketch showing the top of a tent and the positions of the four figures. This was evidently sufficient to enable the illuminator to recognise the conventional image required.
BL. Royal MS. 19.D.III, vol.I, f.20r, detail.

in New York, M.81, made c.1187. They have over a hundred drawings of animals which correspond, and the link cannot be coincidence: either the London book was copied from the Morgan manuscript, directly or indirectly, or both were copied from a third book. Sometimes illustrated texts appear to be such close facsimiles of each other that at first glance the books are virtually indistinguishable. This is particularly true of manuscripts made in monasteries, as one might expect, where the scribes' exemplars were still present while the artists were working. If the exemplar was very old, the compositions of the pictures might emerge in a more up-to-date style or manner. A famous example is British Library, Harley MS. 603, a Psalter written in Anglo-Saxon Canterbury with illustrations copied from an already 200-year-old ninth-century French manuscript, which belonged then to Canterbury Cathedral Priory (it is now in Utrecht, Bibliotheek der Rijksuniversiteit, cod.32, known therefore as the Utrecht Psalter). The eleventh-century copy echoes the archaic exemplar page by page, and there can be no doubt that the precious Utrecht Psalter itself was studied and even propped up in the workshop in the cloisters of Canterbury.

In the later Middle Ages the exemplar was not necessarily available for lending to the artist. This must often have been a real problem.

Des .iij. anges qui lapparurent a abraham se
lon la bible.

De rechief sapparut nostre sire a a
braham en la valee mambre. ou
il seoit a luis de son tabernacle
en la chaleur du iour. Et abraham leua
ses yeulx. si lui apparurent trois hommes
estans decoste lui. Et quant il les vit il leur
ala a lencontre de luis de son tabernacle. Si ao
ra en terre. voir lun deulx. sicomme dit le mai
stre es hystoires. glose. Cy dit iosephus que
dieux y enuoya trois anges en semblance
humaine afin que lun anoncast a abraham
de son filz auenir. et que les deux abatissent
sodome. texte. et dist. Sire se iai trouue
grace en tes yeulx. ne trespasse mye ton ser
gant. car ie apporterai vn pou de yaue a la
uer vos piez. si vous reposerez desoubz cest ar
bre. Je vous donrai du pain si reconforterai
vos cuers. et puis vous en irez oultre Ilz
distrent fai ce que tu as dit. Lors sen ala
hastiuement abraham a son tabernacle a

55

Sometimes quite detailed written instructions would have to be given in or beside the blank spaces left by the scribe. These were meant to be erased but occasionally survive, partially legible. An example in the British Library is Cotton MS. Nero E.II, a Parisian manuscript of the *Chroniques de France* from the beginning of the fifteenth century. On f.238v of its second volume, for instance, is a miniature of a king on his throne receiving a letter from a kneeling cardinal. In the lower margin, only partly erased, one can make out a few words of several lines in French, '*1 roy assis ... ung cardinal qui [vient] du pape ...*', etc., evidently describing the scene for an illuminator who did not know the subject and did not have an exemplar to copy. In other manuscripts the subjects were so standard that almost any artist would know them with only the very slightest of hints. Experience or a standard pattern-book would provide knowledge of the composition needed. An illuminator, accustomed to illustrating Books of Hours, for example, would know from a tiny guideword, such as '*rois*' or '*la fuite*' that the space required a regular picture of the Adoration of the Magi or the Flight into Egypt, with all its apparatus of detail (pl. 55). Such notes presuppose that the artist could read. In thirteenth-century Paris, when the separation of scribe and professional artist first became standard (and presumably when literacy was not universal), the subjects were often indicated by tiny thumbnail diagrams in plummet – a crown for a king, two horns for Moses, a basket for the scene of St.Paul being lowered down from the walls of Damascus, and so on. A few strokes would often be enough to designate a subject. Such shadowy marks in the margins are actually not especially rare, presumably because they were so slight as to be generally unobstrusive (pl. 54). They were sufficient to instruct an artist to fill the space with a specific subject.

53. In the late fifteenth century, devotional manuscripts were sometimes illustrated with woodcuts or other single-sheet images pasted into spaces prepared for them. In this Dutch prayer-book, the picture has become detached. The designer's written instruction is revealed beneath, "veronica", informing us that the image required was the Holy Face of Christ.
BL. Add.MS. 31002, f.34r.

56

How manuscripts were illuminated

Drawing the decoration

Medieval miniatures were drawn first, often very precisely, before they were illuminated and coloured. This preliminary composition is called the underdrawing. A modern painter might regard it as rather unprofessional to have to fill in a picture in careful outline on a canvas before beginning work, but an artist in the Middle Ages saw no shame in producing a finished drawing which would then be entirely covered up by gold and paint (pls. 56–59). We can see medieval underdrawings by a variety of means. The most sophisticated method is to photograph a miniature by infra-red spectoscopy, which can reveal metal-point designs beneath the paint with quite extraordinary clarity. Sometimes, however, we can see them by simply shining a bright light through the page, or even by looking at the reverse side of the leaf (especially if it happens to be blank), which often shows the outlines of ink underdrawing visible through the parchment. Sometimes too, of course, work on illumination was abandoned in an unfinished manuscript and underdrawing survives uncovered, often remarkably beautiful in its nakedness.

To judge from what is still visible, the underdrawing was generally done in two stages. First, the basic composition would be sketched in very quickly, either with a hard point or plummet or even in charcoal. (The change of type of drawing instrument corresponds more or less with the change during the eleventh century of the implement used for ruling guide lines.) This lightning sketch was then re-worked over, usually in thin ink and often in great detail, putting into place the different areas of design to be coloured. The advantage of executing the final design in pale ink rather than in plummet was that it was more visible and yet could be painted over more easily, without granules of metal or carbon showing through the pigment. The first sketch must sometimes have been erased or brushed off, leaving the ink design ready for the application of paint.

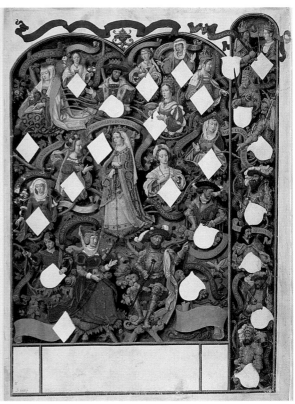

56–57. This is an illustrated genealogy commissioned in Bruges around 1530 for the brother of
the king of Portugal. It was left unfinished when the patron died in 1534. These two adjacent
pages show the two stages of production. The designs were meticulously drawn first by the
Portuguese artist Antonio de Hollandia. Then they were illuminated over the drawings by the
great Flemish painter, Simon Bening. The spaces for coats-of-arms are still left blank, awaiting
the services of a suitable herald.
BL. Add.MS. 12531, ff.11 and 10.

58–59. Five hundred years earlier, an unfinished Gospel Book from Normandy shows similar careful drawing of every detail of the pictures before the page was passed to the artist for illumination. These are frontispieces of the evangelists writing their Gospels, St. Mark and St. Matthew. *BL. Add.MS. 17739, ff.69r and 18r.*

The underdrawing itself may show evidence of its construction. Little holes still visible in the centre of arches and circles show how pairs of compasses were often used (pl. 60). The elaborate knotwork patterns of interlaced ornament in early and romanesque manuscripts were often built up from quite simple combinations of repeated arches and curves. The dazzlingly intricate designs of initials may be put together from a finite number of shapes.

A question which is at the absolute core of art history is that of defining and recognising originality. A medieval painter would not necessarily strive to be original. On the contrary, he might be judged by his craftsmanship and his dexterity in reproducing or even plagiarising the work of others. Innovation was mistrusted. This is true of many aspects of medieval culture. However, every illustrated text had to have an ultimate original. Illustrations can be copied from each other but at some moment the chain has to begin. An ancient legend of the illustrating of an early Irish Gospel Book is recounted by Gerald of Wales in his account of Ireland, written around 1185–90. He says that a Gospel Book was written in the days of St.Bridget of Kildare – in the early sixth century, therefore. The scribe was visited by an angel who showed him a figure incised on a tablet and asked him if he could copy it as the frontispiece of his manuscript. When he said he could not, the angel told him to secure the prayers of St.Bridget, so that God could guide his hand. The scribe did so, and this and many other designs were thus successfully reproduced into the Gospel Book and the decoration was finally completed, Gerald says, by the showing of designs by the angel, by the prayer of St.Bridget, and by the copying of the scribe – 'scriptore imitante'.

This story tells us several things. It cleverly evades the responsibility of artistic originality by attributing the compositions to an angel. The scribe, who was also the artist (Gerald was writing in the late twelfth century), is praised for his ability to imitate. The ultimate exemplars, finally, had been drawn in outline on tablets.

Wax tablets were used throughout the Middle Ages for ephemeral writing and drawing, and we must suppose they were often used for premilinary sketches for illuminations. Patternbooks, sometimes actually in the form of tablets, were certainly used by artists as pictorial quarries for individual elements of illuminations – a little animal, a tree, a bunch of foliage, a face. Others were used as models for ornamental initials and borders. An English patternbook of about 1450 is

60. (OPPOSITE) In making the preparatory drawings, artists must have used rulers and compasses. Tiny holes from the tip of a pair of compasses (or dividers) can be seen here in the centres of each of the four arches at the top of this eleventh-century page of columns for canon tables. *BL. Stowe MS. 3, f.5v.*

British Library, Sloane MS. 1448A, with a wide range of flamboyant initials and foliate borders (pl. 61). By the end of the Middle Ages, artists were making great use of widely-circulated engravings to provide elements of design, which must have been cheaper than owning one's own patternbook. Mostly the compositions in surviving patterns are simply in outline, like the angel's tablets, for they were models for the underdrawing.

The transference of the drawing from its model into the blank space on the page of the new manuscript could be achieved by several methods. A good artist would surely copy by eye. The horizontal grid of ruling lines already on the page would help give a framework for setting the proportions. Other designs were traced. Medieval craftsmen's manuals give instructions for making tracing paper, usually called 'carta lustra', often made of kid parchment. There is some evidence that tracing was used in making manuscripts as early as the ninth century. Sometimes where we have the model and the copy taken from it, the measurements of the exemplar correspond with such precision to those of the copy that we must suppose the design was transferred by tracing. In some manuscripts the drawings were traced from within the book itself. Canon Tables in Carolingian Gospel Books, for example, repeat the same design from page to page, with great arches set on tall architectural columns. If the artist could draw it once, he could then trace the outlines through the parchment onto the next and subsequent pages. The borders of French Books of Hours in the fifteenth century often reproduce designs exactly from the recto to the verso of pages – precisely the same little flowers, birds and grotesques copied in outline through the pages, emerging on the other side in mirror-image, perhaps (it has sometimes been suggested) with the help of a light shining through the parchment (pl,. 62–63).

61. Many professional illuminators evidently had patternbooks with repertoires of designs for illuminated initials and ornaments. This English example dates from the mid-fifteenth century. The page shows ideas for initials for letters N–S in the alphabet.
BL. Sloane MS. 1448A, f.22v.

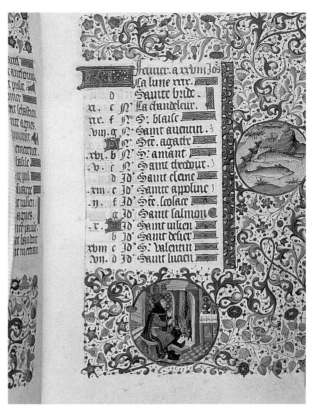

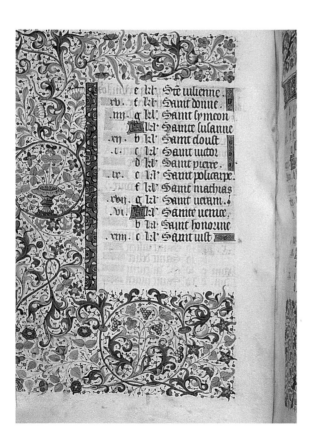

62–63. These are both sides of the same leaf in a Calendar of a Book of Hours, made around 1440. On the first page the artist designed a border of coloured flowers and acanthus leaves around medallions with the scenes for the month of January. When he painted the other side of the same leaf, he simply traced the exact compositions and patterns, which now emerged in reverse. The medallions have become roundels in the decoration.
BL. Egerton MS. 2019, ff.2 and 2v.

Only the outlines were traced, for when they were subsequently painted there is no correspondence of colour. Similarly, of course, if it is technically possible to trace outlines through the thickness of parchment, it must sometimes have been easier to place the whole new page directly on top of the exemplar or patternsheet and to trace directly through the leaf itself.

Some manuscripts (especially Bestiaries) now have the outlines of their pictures pierced with rows of tiny holes, and we can assume that these occurred when making templates for the copying of pictures by pouncing. In this method, a sheet of paper or parchment would be placed behind a page of the exemplar. The artist would prick a row or pattern of holes around the edges of the upper composition right through the page and into the sheet beneath. The loose leaf below would then work like a stencil. It could in turn be placed on top of the page of a new manuscript and could be dabbed over with charcoal or colour, printing through the holes a design in dotted lines. Some caution, however, is needed before asserting too categorically that pouncing holes in miniatures necessarily show that the particular book was used as an exemplar for another manuscript: pricked holes themselves cannot be dated, and pictures of animals, for example, might be transferred by later pouncing into any variety of other purposes, including embroidery or wall decoration. There is a record that in 1383 the painter Jean de Bruges borrowed an illustrated Apocalypse from the royal library of Charles V to use as an exemplar, not to make another manuscript but to make designs for tapestries. If only we had as many surviving medieval works of art as we have manuscripts, we might find frequent examples of pictures copied from one artistic medium to another.

Gold

There is no doubt that in the Middle Ages gold was a glamorous material. It was a symbol of royalty. It represented wealth and status. From the Harley Golden Gospels (British Library, Harley MS. 2788) to the Field of the Cloth of Gold, it was part of the panoply of medieval kingship. Gold was treasure. In the Hastings Hours, the ultimate nobility of the Three Kings is represented by royal attendants on a balcony emptying apparently unlimited sacks and armfuls of gold on the grateful populace below (British Library, Add.MS. 54782, f.43r). The word

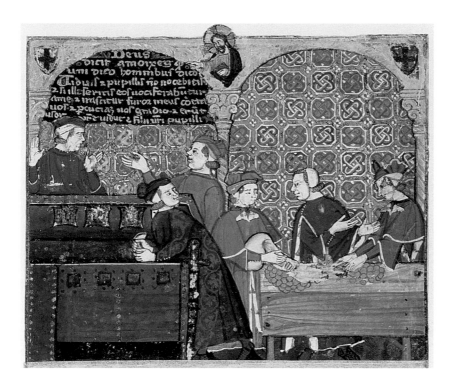

64. Gold was always a precious commodity in Europe. This late fourteenth-century Genoese miniature shows bankers taking bags of gold from a great chest and emptying the coins on a table.
BL. Add.MS. 27695, f.8r, detail.

'gold', *'aureum'* in Latin, was used to give the highest status to book titles, for example, to confer both honour and a sense that the text was itself a treasury able to dispense wealth. The definitive volume of saints' lives collected by Jacobus de Voragine was known as the 'Golden Legend', the *Legenda Aurea*. The most admired late medieval Gospel commentary, that of Thomas Aquinas on the Gospels, was called the 'Golden Chain', *Catena Aurea*. The most catholic of sermon collections, those of Johann Nider, circulated as the *Aurei Sermones*. The title of gold made a statement about the book in the hierarchy of texts.

Actual gold is used a great deal in medieval manuscripts. From the early centuries of Christianity, opulent Gospel manuscripts were sometimes written entirely in gold, exalting the whole text. In the period of the great Carolingian and Ottonian emperors, from the eighth to the eleventh century, the most spectacular and imperial of manuscripts acquired extraordinary status by lavish use of shimmering gold and silver. Carolingian book inventories, famously reticent in noting the appearance of books, never failed to be impressed by gold: Gospel Books and Sacramentaries, for example, were described as *'aureis literis decoratis'* at St-Wandrille and *'cum auro scriptum'* at

65. The great Anglo-Saxon manuscript Benedictional of St. Aethelwold, bishop of Winchester 963–84, includes an illuminated portrait of the patron receiving the book bound in gold. The dedication inscription to Aethelwold draws attention to the use of gold throughout the book.
BL. Add.MS. 49598, f.118v, detail.

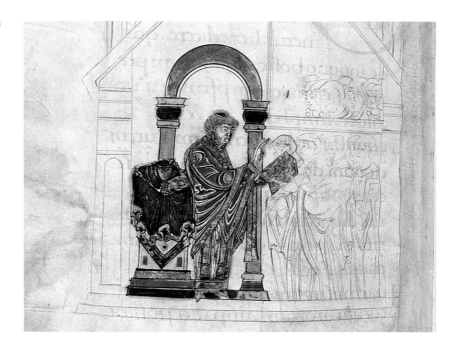

Cologne in the ninth century, and as *'cum auro pictum'* at Lorsch and *'auro parata'* at Regensburg in the tenth century. It is a fact that most Carolingian and romanesque manuscripts do not actually include gold. The very extravagant manuscripts therefore stood out as memorable and royal by their use of golden initials or pictures. The dedication inscription of the magnificent Benedictional of St.Aethelwold, bishop of Winchester 963–84, records that the great patron not only had the book adorned with pictures but even had it ornamented with gold, *'necon simul auro'* (British Library, Add.MS. 49598, f.4v (pl. 65)). As late as the 1180s, the dedication poem in the Gospels of Henry the Lion specifically refers to the manuscript's use of gold to bear witness to the imperial associations of its patron (Wolfenbüttel, Herzog August Bibliothek, Cod.Guelf. 105 Noviss.2°, and Munich, CLM. 30055, f.4v).

What is infinitely more remarkable to us, however, is not the occurrence of gold in rare and extravagantly expensive manuscripts of the early Middle Ages, but the extreme commonness of gold illumination in late medieval books (pl. 66). Straightforward student textbooks of the thirteenth or fourteenth century would be quite likely to open with an initial which includes burnished gold. Late medieval reference books as utilitarian as medicine and law, for example, are often decked with gold initials, large and small. Little pocket-sized

Psalters of the late thirteenth century, made in huge numbers for relatively humble patrons, often use burnished gold initials for the opening of every single verse of the Psalms – just over 2,500 initials in a small volume of no great extravagance. The most common manuscripts of the fifteenth century are Books of Hours. Even the least expensive copies, without miniatures, would generally have burnished gold on almost every page in initials and line-fillers and probably borders. Gold appears frequently as one of many colours employed in miniatures, especially for depicting metallic objects, like crowns, or for showing what is not seen in normal sight, like haloes or featureless backdrops. The very widespread use of gold in gothic manuscripts represents a complete change from books of the early medieval period, and indeed distinguishes them from those of our own time.

Gold became a major element in defining status in the hierarchy of ornament within a manuscript. Initials were graded in relation to each other not just by size but also by varying amounts of gold. The employment of a greater or lesser amount of real gold was the clearest symbol of rank, far more explicit than the use of any other colour. Gold, furthermore, as we saw above, had fundamental medieval associations with financial status and the distribution of largesse: any section of a text introduced by the actual presence of gold was endorsed as a giver of wealth. One can see the varying extent of gold in the initials on almost every page of any standard fifteenth-century Book of Hours. The one-line initials for each verse had the most humble status in the hierarchy. In very many manuscripts they are executed in alternating patterns, either formed of burnished gold in a bed of black penwork, or painted in deep blue within a surround of red penwork. At this level, blue and gold are of equal rank; red and black are secondary colours. The next level up the scale would have initials (perhaps 2 lines high) formed of burnished gold, outlined in black ink, set on painted panels of blue and pink heightened with a tracery of white lines. Such initials are absolutely standard in late medieval Europe, in every country and in nearly every text. The initial is formed of burnished gold: the surround is a little rectangular box of blue and red (or pink), in equal amounts, covered with ornamental lines in white ink. Literally millions of initials in this precise design must have been illuminated in the fifteenth century. The third rank upwards in the hierarchy (and size) would have the initial itself in blue or pink with white tracery, enclosing (perhaps) flowers in many colours or a picture, on a

66. (OPPOSITE) Gold was used very extensively in illuminated manuscripts of the gothic period. This is a north-eastern Italian Bible of around 1300. The gold leaf is applied over raised gesso so that it appears to be thickly encrusted on the page, and it catches the light and sparkles as the leaves of the manuscript are turned.
BL. Add.MS. 18720, f.410r.

67. (LEFT) By the late Middle Ages, the most common use of gold in daily life was in coinage. Illuminators sometimes hammered coins into gold leaf for use in decorating manuscripts. The gold coins shown here are from the Fishpool Hoard, and date from the third quarter of the fifteenth century. *British Museum, Department of Coins and Medals.*

whole panel – this is important – formed of burnished gold. A low grade initial is formed of gold set in the midst of colour; a high ranking initial is in colour on a ground of gold.

Two factors probably affected the rapid increase in the use of gold in manuscripts after about 1200. One is that gold leaf as a substance is extremely fragile and almost weightless and it is impossible to manipulate where there is even the slightest breeze. Before 1200, very many books were made in communal cloisters, open to the air; by the thirteenth century, however, professional illuminators commonly worked at home and indoors, and in the absolute stillness of an enclosed studio it would be much easier to illuminate with gold. The second factor is simply the availability of gold. This is very significant. There was a great deal of gold in the ancient world, mined especially in Egypt and along the coasts of northern Africa. Roman gold coins must have been quite common, even in the Middle Ages. By the beginning of the eighth century, however, all of north Africa and most of Spain and parts of southern France had been conquered by the Muslims. The supply of mined (or reef) gold to Europe ceased abruptly. Trade routes through the Middle East were closed. A small amount of alluvial gold was dredged in the Rhine and other European rivers, but it was costly to extract. Any gold used in manuscripts was probably obtained by melting down antique artefacts, not a secure source of supply. No European principality minted gold coins after the early eighth century. The Carolingian and Ottonian economies were based on silver, not gold; it is no wonder that golden manuscripts were rare, exceedingly expensive, and much admired. In the early thirteenth century, however, the gold route re-opened. Constantinople

was reconquered by the crusaders in 1204; and the Muslims were driven from Spain. Gold rapidly re-entered Europe. Gold coinage was tentatively reintroduced into Italy by the emperor Frederick II (1215–50), into France by Louis IX (1226–70), and into England by Henry III (1216–72). Gold was discovered in Slovakia, then part of the kingdom of Hungary, in 1320, and the west African mines along the Gold Coast were in operation by the mid-fifteenth century. By the late Middle Ages, gold was once again plentiful in Europe and the manuscripts sparkle with illumination.

Gold leaf is made by hammering the metal over and over again until it is infinitely thin, almost without substance or thickness. There is medieval evidence that goldbeaters used current coins as a convenient supply of gold, such as ducats or florins (pl. 67). By the late Middle Ages it was available commercially, and it still is. 'If you want to be sure of the gold', wrote Cennino in his fifteenth-century artists' manual, the *Libro dell'Arte*, 'when you buy it, get it from someone who is a good goldbeater; and examine the gold, and if you find it rippling and matt, like goat parchment, then consider it good'.

Gold was applied into manuscripts by two principal methods, either as gold leaf, laid over an adhesive and afterwards burnished, or mixed into a kind of gold solution. This latter gold is really a paint, and it was usually applied at the very end of the process of decorating a manuscript. We will return to it below. In the meantime, let us focus on burnished gold. Gold leaf is pure gold, or as pure as it could be refined in the Middle Ages. Unfinished manuscripts show that gold was always the first colour applied after completion of the underdrawing. This is dictated by common sense. Gold leaf would cling easily to any rough texture and would adhere inappropriately to any painted area already executed. It would need to be applied first before any other paint. For this reason alone, all parts of the underdrawing would have to be final and immutable for, in laying the gold, the illuminator would necessarily need to pick out isolated and detached elements of the whole composition – a halo here, a sword there, a gold sun, a hem of a robe, a spray of free-floating ivyleaves without their stalks, and so on. Once again, the years around 1200 provide a turning point in manuscript-making techniques. Before about 1200, gold (if used at all) was generally applied flat, directly onto the page. The design would be exactly painted onto the page in a gum or glue and a whole sheet of gold leaf would be laid on top. When dry, it could be

brushed away and would cling to the page wherever it had been painted with adhesive (pls. 68–69). From the early thirteenth century, however, illuminators started laying gold leaf over raised gesso. This was formed of slaked lime and white lead, usually mixed with a pink or red-brown clay, called Armenian bole, with a little sugar and sometimes a dash of gum. Gesso like this could be formed into little pellets and kept until the illuminator was ready to begin work. When needed, the gesso mixture was ground into a solution with egg glair, a very effective glue formed from the froth of beaten egg whites. This liquid pink substance could then be painted onto the manuscript page in the exact shapes required by the design of the underdrawing. It could be puddled onto the parchment quite quickly and then gently edged with a pen or tip of a brush into the outlines prepared for it, building it up layer upon layer into a thickly raised design. The pink colour would make the gesso clearly visible on the page. It would take some time to dry. Probably the gold leaf could not be laid on top until at least the following day. The fragile sheet of gold would be lowered carefully over the gesso and pressed down through a piece of silk or fine parchment. When it was completely dry the gold was burnished. This was done with a tool often called a dog's tooth, which it sometimes literally was – a very hard and highly polished knob, made either of a tooth or stone attached to a handle. The tool was rubbed vigorously back and forth across the new illumination, round its edges and into its contours, pushing the gold leaf into place, smoothing its surface and buffing it up into a brilliant finish (pl. 70). In doing so, any overlapping edges of gold leaf would crumble away and could be brushed away from the page. This might leave a rather ragged edge to the illumination: as a finishing touch, the illuminator would often draw a black outline in ink around the gold, to conceal the frayed edges and to crisp up the whole effect. Gold in manuscripts often looks very thick, like globules of molten metal across the page. It is, of course, exceedingly thin but is laid over the raised gesso. If it should ever wear away on its upper surface, the colour of the bole shows through and imparts a mellow pink or brown patina. Because the surface of the gold is curved like a cushioned mirror, it constantly sparkles and catches the light. Unlike silver, gold never tarnishes. There is no doubt that the use of gold adds glamour and, to those of us accustomed to printed books, gives a rare and wonderful effect of moving light as one turns the pages of a medieval manuscript.

68–69. The sequence of illumination is illustrated in a series of similar initials in a partly unfinished manuscript of short theological texts made in western England in the second half of the twelfth century. The initial was sketched in plummet and then redrawn in ink (f.11r). Brown pigment (bole) was added into the spaces where gold would be needed. In manuscripts earlier than the thirteenth century, this brown ground was applied directly onto the page, not built up with gesso (f.45r). Gold leaf was laid onto the bole (f.12r). Once that has been burnished until it shines, other colours can be added around it (f.20r).
BL. Royal MS. 6.E.II, details.

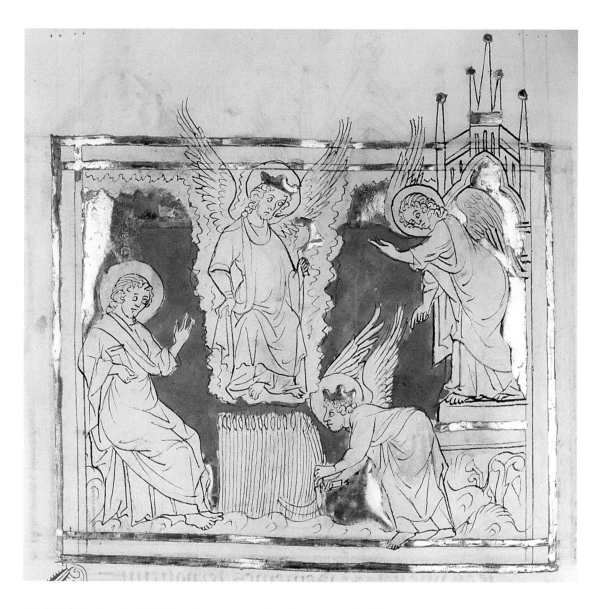

70. This is from the unfinished thirteenth-century Apocalypse shown in plates 5–8 above.
The gold has been laid over gesso, so that it appears to be thick on the page, and it has been
burnished into a shine. The artist can then begin to apply other colours, beginning with
the pale red background.
BL. Add.MS. 42555, f.51v, detail.

Colours

One might imagine that the choice of colours in any picture would be obvious before the artist mixed up his pigments – that the sky or the sea would be blue, the grass green, faces pink, and so forth. A medieval artist, however, was not necessarily seeking realism (pl. 72). A sky might be gorgeous in deep purple with gold tracery, a face might stand out better in bright green, and the water of the Red Sea, of course, would be have to be red so that it could be recognised. Generally, the evolution of realism in manuscript painting follows that of the other pictorial arts in Europe, and style evolved towards a gradual appreciation of naturalism during the renaissance. It is possible, however, to paint naturalistically without colour, or with colours that are not found in reality. Some of the most skilful fourteenth- and fifteenth-century illuminators, such as Jean Pucelle and Simon Marmion, sometimes opted to avoid colours altogether, stepping back into a dream world of grisaille, formed of delicate tones of grey, or into semi-grisaille, with (perhaps) the figures in grey but with splashes of brilliant colour dramatically lighting up the backgrounds.

Remember the clear distinction between designing the manuscript and the eventual filling in of the colours. In some manuscripts, the choice of colours was already selected when the pictures or initials were planned. It is often difficult to imagine why. As early as the ninth century we find tiny code letters with instructions on the colours needed. An example is a Carolingian Aratea in Cologne (Dombibliothek, Cod. 82.II) with little notations in red chalk giving colours for the pictures of the constellations , 'vir' for green (*viridis*), 'ocra' for yellow, 'nicri' for black, and 'brunus' for brown. In a number of twelfth- and thirteenth-century books, including a glossed manuscript perhaps made at Winchester and a French Bestiary, the areas of colour within miniatures can be seen to have been painted over tiny letters of the alphabet, 'r' beneath areas painted red, 'v' or 'G' beneath green, 'a' beneath blue (azure), and so on (Oxford, Bodleian MS. Auct. D.1.13, and Los Angeles, J.Paul Getty Museum, MS. Ludwig XV.4). Presumably one person designed and drew out the pictures, and marked them up for another to add the appropriate colours. What is fascinating is that they evidently cared whether one part of a garment in a miniature was shown in one colour and another in a different colour. It must have been the range of colour which they wanted

to show, conveying hierarchy by the breadth of the spectrum used. British Library, Royal MS. 6.E.II, is a volume of theological texts, perhaps from Gloucester, of the second half of the twelfth century. It has no miniatures at all, but simply coloured initials. In the final gathering, ff.169–176, a designer has marked little letters in red ink beside the 2- to 3-line chapter initials, 'V' beside initials that are now painted green (pl. 71), 'R' beside those that are red, and 'A' for those that are blue. There is no apparent textual significance why any one of these initials should be obliged to be painted in any particular colour, but evidently it was important in the design of the book that there should be three alternating colours.

There are a surprising number of medieval craftsmen's manuals giving instructions for mixing medieval pigments. We can also recognise colours scientifically by a variety of means, including Raman microscopy, which can identify the composition of pigments by analysing the spectra of light reflected off a tiny area of a manuscript illumination. The advantage of this method is that it is completely non-destructive. Its main problem is that is very slow and requires vastly expensive equipment. There are two natural sources of medieval colours, minerals (pl. 73) and plants (pl. 74). Inorganic or mineral pigments include blues and greens made from *verdigris* ('green of Greece'), copper acetate – $Cu(O_2CCH_3)_2.2Cu(OH)_2$; the commonly found *azurite*, copper carbonate – $2CuCO_3.CU(OH)_2$; and *lazurite*, the famous and precious blue from lapis lazuli – $Na_2[Al_6Si_6O_{24}]Sn$. Lapis is found only in the region of Afghanistan, and its popular name *'ultramarine'* has nothing to do with the colour of the sea but rather that it came from beyond the seas, from the other side of the world. It is used even in the Book of Kells and the Lindisfarne Gospels. Red could be formed from red lead or *minium*, lead oxide – Pb_3O_4; or from *cinnabar*, mercuric sulphide – HgS, found in Spain, Italy and elsewhere, very poisonous, or its close variant *vermilion*, made in the Middle Ages by a process of heating mercury and sulphur; yellow from *orpiment*, arsenic sulphide – As_2S_3; and white from *lead white*, lead carbonate – $2PbCO_3.Pb(OH)_2$. Organic or vegetable pigments were extracted from a wide selection of plants, such as saffron for yellow, the madder plant for a rather purplish red, indigo for blue, and so on. The plant turnsole, or *folium*, was used for a whole range of colours from blue to red, depending on whether it is acid or alkali (for it changes, like litmus paper). Often paints made from turnsole look purple.

71. This is from the same twelfth-century manuscript as plates 68–69. The designer has indicated the colours to be used for small initials. The little "v" in the margin here must stand for a word such as *'viridis'* or *'vert'*, meaning 'green'. Other coloured initials in the book are similarly marked with "r" beside those painted red and "a" (azure) beside those in blue.
BL. Royal MS. 6.E.II, f.177r, detail.

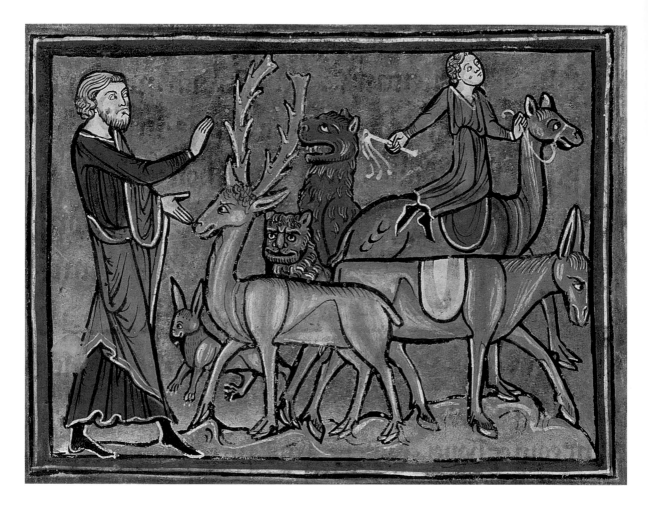

72. Often the colours of medieval miniatures bear little relation to reality. In this early thirteenth-century Bestiary, once at Rochester Cathedral, a group of animals is arranged without regard to natural colour, scale or perspective, all against a burnished gold ground. *BL. Royal MS. 12.F.XIII, f.34r, detail.*

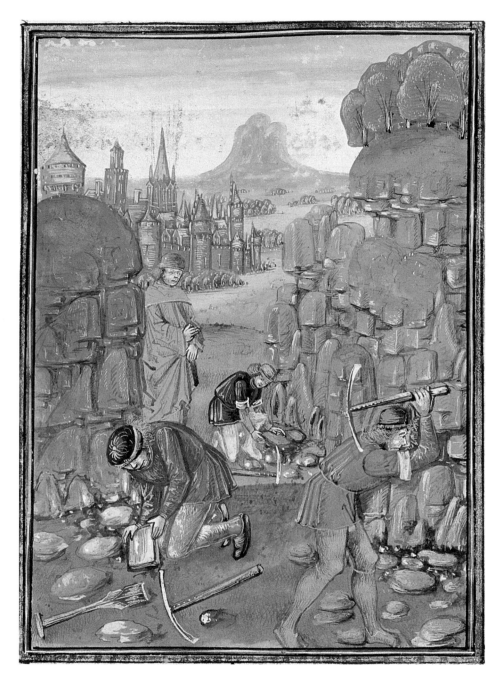

74. Plants provided many pigments used in medieval manuscripts, including extracts from flowers, leaves, roots and bulbs. Late medieval artists often included detailed pictures of flowers and plants in the borders of manuscripts. The realistic lilies here are in the margins of a fifteenth-century German Breviary.
BL. Egerton MS. 1146, f.293r, detail.

73. The colours used in medieval pigments were made from two principal sources – plants and minerals. Ground-up stones and coloured earths provided many colours. This northern French illustration of about 1480 shows miners excavating in a quarry.
BL. Stowe MS. 17, f.84r, detail.

Medieval illuminators probably often would not need to know the compositions of pigments, which were doubtless often bought as powders from the shops of apothecaries. The ingredients were transformed from raw pigment into paint by grinding them and mixing with fish or animal gums or, especially, with egg. The white of egg makes glair, transparent and easy to use; the yellow forms egg tempera, which imparts a richness to the colour. The illuminators would doubtless prepare their own combinations of colours. Some pigments are chemically incompatible with each other. Lead white is especially difficult to combine with other materials. Mixed with verdigris it becomes corrosive and eats through the pages; mixed with yellow orpiment it turns to lead sulphide and with azurite it turns to copper sulphide, both of which are black. If lead white is used in a miniature in proximity with an incompatible component, the illuminator will leave a fractional space between the areas of pigment, perhaps separating them with a black line.

A manuscript artist worked from the prepared underdrawing. The burnished gold would already be in place when he began inserting the colours. Sometimes an artist would begin at the top of the design, working downwards. Areas of colours would be roughly blocked into shape. If several miniatures were needed within a single gathering, the painter might insert one colour across the range of several pages at one time. Gradually, using paler and darker mixtures of the same pigment, draperies would be modelled, backgrounds crisped up, and highlights added, including hatching or dotting in white. Quite often human faces seem to have been left to the end, either because a different artist was involved or because of the pleasure in holding back the moment of suddenly bringing a picture to life.

Burnished gold, as we have seen, was often the first colour on a page. Sometimes liquid gold supplies the final touch, especially in manuscripts from the very end of the Middle Ages. This was gold ground into a powder and mixed with a binding medium, like any mineral paint. It was more expensive than gold leaf, and it required a larger amount of raw gold. It is sometimes called 'shell gold', since it was commonly poured into a container formed of an old sea shell. In the hands of a good artist, a few careful touches of liquid gold can add dazzling highlights to a picture. A poor illuminator (and there were some) could spoil the effect of his picture by over-use of liquid gold at the final stage.

In the end, when all the initials and miniatures were completed, the loose gatherings of the manuscript would be returned to the designer or co-ordinator of the book, who had undertaken it in the first place. He would assemble its gatherings into order, check the miniatures, clean up the margins and erase any guide letters or instructions to the artists (so precious for us if he should miss some), and would generally tidy the book. This whole activity is sometimes recorded in stationers' accounts, as in 1397 when the Parisian book-seller Pierre Portier charged extra *'pour avoir nettoyé, blanchy, corrigé'* a newly-written Book of Hours before binding it. If we buy a book today, there is an agreeable sense of newness. The book is unopened and it cracks slightly as we fold open the pages for the first time. In the Middle Ages, every page of a new book had already been handled very many times before the volume was first cradled by its patron. Its page layout had been calculated, the pages had been folded and cut into gatherings, holes had been pricked, lines had been ruled on every page, initials and pictures had been marked out and their subjects indicated, the script had been written by hand probably in red as well as black, decoration had been drawn in several stages, gold had been laid and burnished, and colours had been applied, layer after layer. It was a handmade book, and every stage of its making had a purpose.

75. This is from the chronicle illustrated in pls. 39–40. The gold illuminated frame has been burnished. The artist has begun filling in the colour from the top, working downwards. *BL. Royal MS. 20.C.VII, f.104r, detail.*

76. Patrons were sometimes depicted in books in idealised images of the manuscript in use. Here the owner of an early fifteenth-century Book of Hours kneels before her newly-made book which has been wrapped in gold and blue cloth.
BL. Harley MS. 2952, f.19v.

77. (OPPOSITE) The completed book was finally bound up and delivered to the customer. There are many scenes in manuscripts of books being presented by their authors to noble patrons. The miniature here shows Pierre Louis de Valtan giving a book to Charles VIII, king of France.
BL. Add.MS. 35320, f.3v.

Further reading

J.J.G. Alexander, *Medieval Illuminators and their Methods of Work*, New Haven and London, 1992

J.J.G. Alexander, *The Decorated Letter*, New York and London, 1978

J. Backhouse, 'An Illuminator's Sketchbook', *British Library Journal*, I, 1975, pp.3–14

J. Backhouse, *The Illuminated Page, Ten Centuries of Manuscript Painting in the British Library*, London, 1998

L. Brownrigg, ed., *Medieval Book Production, Assessing the Evidence*, Los Altos Hills, 1990

D. Byrne, 'Manuscript Ruling and Pictorial Design in the Work of the Limbourgs, the Bedford Master, and the Boucicaut Master', *Art Bulletin*, LXVI (1984), pp.118–36

R.J.H. Clark, 'Raman Microscopy, Application to the Identification of Pigments on Medieval Manuscripts', *Chemical Society Reviews*, XXIV (1995), pp.187–96

M. Clarke, *The Art of All Colours, Mediaeval Recipe Books for Painters and Illuminators*, London, 2001

C. de Hamel, *Scribes and Illuminators*, London, 1992

L.M.J. Delaissé, 'The Importance of Books of Hours for the History of the Medieval Book', *Gatherings in Honor of Dorothy E. Miner*, ed. U. McCracken, L.M.C. Randall and R.H. Randall, Baltimore, 1974, pp.203–25

J.D. Farquhar, *Creation and Imitation, The Work of a Fifteenth-Century Manuscript Illuminator*, Fort Lauderdale, 1976

J.B. Friedman, *Northern English Books, Owners and Makers in the Late Middle Ages*, Syracuse, N.Y., 1995

O. Pächt, *Book Illumination in the Middle Ages, An Introduction*, London, 1986

K.L. Scott, 'Limning and book producing terms and signs *in situ* in late medieval English manuscripts, A first listing', *New Science out of Old Books, Studies in Manuscripts and Early Printed Books in Honour of A.I. Doyle*, ed. R. Beadle and A.J. Piper, Aldershott, 1995, pp.142–88

R.W. Scheller, *Exemplum, Model-Book Drawings and the Practice of Artistic Transmission in the Middle Ages (ca.900–ca.1470)*, Amsterdam, 1995

D.V. Thompson, *The Craftsman's Handbook 'Il Libro dell'Arte' by Cennino d'A. Cennini*, New Haven, 1933, reprint, New York, 1960

Acknowledgements

Most of this book was written while I was a guest of the Schiller family in the south of France. I am indebted to Laura Nuvoloni for information on unfinished manuscripts in the British Library and to Michael Gullick for my knowledge of the colour codes in Royal MS. 6.E.II. It is customary for an author to acknowledge his publisher. Few have ever been as patient as David Way and Kathleen Houghton of the British Library Publishing Office, who must often have despaired of my ever returning the proofs of this book.

General index

Index of manuscripts